Utrecht Painters of the Dutch Golden Age

Utrecht Painters of the Dutch Golden Age

Christopher Brown

National Gallery Publications, London

First published in Great Britain
in 1997 by National Gallery
Publications Limited
5/6 Pall Mall East,
London SW1Y 5BA

ISBN 1 85709 214 7
525263

British Library Cataloguing-in-
Publication Data. A catalogue
record is available from the
British Library.

Publisher Suzie Burt
Editor Andrea Belloli
Assistant Editor John Jervis
Designer Sara Robin
Printed and bound in
Hong Kong

FRONT COVER Detail of figure 14
Hendrick ter Brugghen
The Concert, c.1626
BACK COVER Figure 13
Hendrick ter Brugghen
*Saint Sebastian Attended by Saint
Irene*, 1625
FRONTISPIECE Detail of figure 6
Abraham Bloemaert
Moses Striking the Rock, 1596

This book was published to
accompany an exhibition entitled
*Masters of Light: Dutch Painters in
Utrecht during the Golden Age* at

The Fine Arts Museums of
San Francisco
13 September - 30 November 1997

The Walters Art Gallery, Baltimore
11 January - 5 April 1998

The National Gallery, London
6 May - 2 August 1998

EXHIBITION CURATORS
The Fine Arts Museums
of San Francisco
Dr Lynn Federle Orr, Curator of
European Painting

The Walters Art Gallery,
Baltimore
Dr Joaneath Spicer,
James A. Murnaghan Curator of
Renaissance and Baroque Art

The National Gallery, London
Dr Christopher Brown,
Chief Curator

Contents

Acknowledgements 6

Sponsor's preface 7

Introduction 9

1 Utrecht in the Seventeenth Century 11

2 Artistic Precursors 17

3 The Mannerists: Abraham Bloemaert
 and Joachim Wtewael 21

4 The Caravaggesque Painters 31

5 Italianate Landscape Painting:
 Cornelis van Poelenburgh and Jan Both 49

6 Genre Painting, Marine Painting and Still Life 53

7 The End of the Utrecht School 57

Biographies of the Artists 59

Suggestions for Further Reading in English 68

Works in the Exhibition 70

Acknowledgements

This small book is intended to serve as an introduction to painting from seventeenth-century Utrecht, the subject of an exhibition to be held in San Francisco, Baltimore and London in 1997-8 with the title *Masters of Light: Dutch Painting in Utrecht during the Golden Age*. The complete catalogue of that exhibition has been extensively consulted in the preparation of this publication. I am indebted to all the catalogue's authors but would particularly like to thank Marten Jan Bok, Lynn Orr and Joaneath Spicer for their generous cooperation.

DR CHRISTOPHER BROWN, *National Gallery, London, May 1997*

Sponsor's preface

No one looking at these paintings in the National Gallery could fail to be aware of the extraordinary confluence of religious, cultural and artistic development which characterised Utrecht during the turbulent years of the seventeenth century. Personally, as a native of the Netherlands, I am fascinated by the pan-European heritage displayed in these canvasses – the influence of the Italians and the Roman Catholic Church combined unapologetically with that of the Reformation.

It is this diversity of the Utrecht school of painting which makes it a particularly attractive choice of sponsorship for SBC Warburg. We are a truly global force in investment banking, employing over 10,000 people in more than forty countries of the world. We advise clients in areas as far apart as Europe, the Asia Pacific and the Americas, on every aspect of financing and securities, helping to fulfil their objectives, short and long term. Like our clients, our staff come from every corner of the globe, often sharing only the universal languages of talent, ambition and drive. We try to encourage talent wherever we find it – not just within our own company, but through our community and sponsorship programmes which focus particularly on the needs of gifted young people struggling against disadvantages – whether economic, social or physical.

Although we in the high-technology environment of the late twentieth century are separated from the Golden Age of Utrecht by almost 400 years of development and knowledge, I believe these artists have something to teach us. Their relentless pursuit of perfection, their willingness to experiment and embrace new ideas whilst retaining the lessons of history and tradition, are an inspiration to any of us.

I hope you share my enjoyment of this superb exhibition.

HANS DE GIER, *Chairman and Chief Executive, SBC Warburg*

Introduction

One of the most distinctive and fascinating features of Dutch painting of the seventeenth century was the vigour and variety of local schools of painting. Not only did the large cities of Amsterdam, Leiden, Haarlem, Rotterdam, The Hague, Delft and Utrecht have flourishing schools of painting; smaller towns such as Alkmaar, Gouda, Enkhuizen and Deventer were also lively artistic centres.

These local schools were sustained by the first art market of modern times, including the now familiar apparatus of dealers and auctions. While the purchase of paintings had formerly been the prerogative of the aristocracy and the Church – and continued to be in much of the rest of Europe during the 1600s – this was not the case in the Dutch Republic. Merchants and artisans, farmers and school-teachers, lawyers and doctors bought paintings from art dealers and at auctions and fairs. Prices, particularly for landscapes and scenes of everyday life, which today are known as genre paintings, were low, and pictures hung in many modest Dutch houses. The nature of the art market determined to a significant extent the types of painting in which artists specialised. For example, an analysis of the inventories of Delft collectors reveals that early in the century there was a demand for pictures of religious and mythological subjects – known as history paintings – but these gradually lost ground to the new secular categories of landscape, still life, church interiors and genre paintings. This change in taste reflected the rise of a new clientele for paintings which was neither Catholic nor educated in classical literature. Many of the greatest works of the Golden Age of Dutch painting – the landscapes of Jacob van Ruisdael and Meindert Hobbema, the genre paintings of Jan Vermeer, Jan Steen and Gabriel Metsu, the church interiors of Pieter Saenredam and Emanuel de Witte, the still lifes of Pieter Claesz. and Willem Kalf – were created in response to this demand. In Amsterdam, the Republic's largest city and its economic powerhouse, Rembrandt initiated a new type of Protestant religious art on a scale which was

Detail of figure 14
Hendrick ter Brugghen
The Concert, c.1626

9

suitable to be hung not on altars in a church but in a domestic setting.

Each of the local schools of painting in the Dutch Republic had its own particular features, which naturally arose from the character of the town in which it flourished. The most distinctive school was that of Utrecht. The Mannerist history paintings of Abraham Bloemaert and Joachim Wtewael, the Caravaggesque religious and genre scenes of Hendrick ter Brugghen, Dirck van Baburen and Gerard van Honthorst, and the landscapes of Cornelis van Poelenburgh and Jan Both are among the most beautiful and important works of the Golden Age. However, because Utrecht painting is so distinctive and in some key respects very different from painting in the other towns of the Republic, it has been difficult to fit into the broader pattern of the Golden Age and so has not received the attention it deserves.

Portraits, genre scenes, landscapes and still lifes were all painted in Utrecht, but what set the city apart was the continuing demand for religious and mythological pictures. The Mannerists of around 1600 and the Caravaggesque painters of the 1620s catered for this demand, which was created by the special religious, political and social character of the city itself.

Detail of figure 9
Joachim Wtewael
Andromeda, 1611

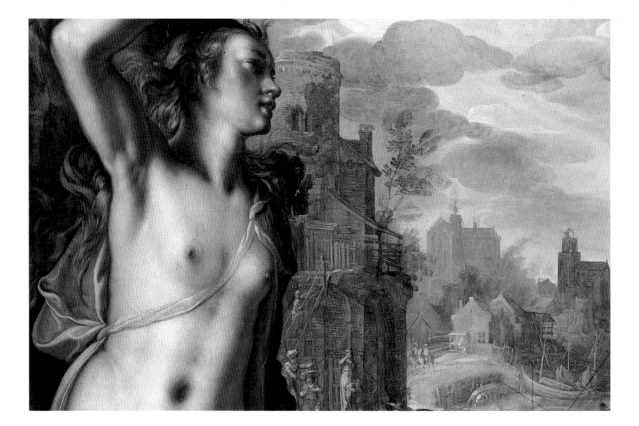

1 Utrecht in the Seventeenth Century

Utrecht is an old city with a proud tradition of independence. It lies on the River Vecht, fifty kilometres from the west coast of the Netherlands and half-way to the German border from Amsterdam or The Hague (FIG. 1). This distance from the other large towns, which form part of a highly developed and heavily populated strip along the west coast known as the *Randstad*, is one of the principal reasons for Utrecht's autonomy. As the capital of the province with the same name, it is a seat of provincial government. It has a distinguished university, founded in 1636, and a great medieval cathedral, the tower of which was the tallest structure in the Netherlands in the seventeenth century. Its distinctive profile could be seen from far away as travellers approached the city from the sandy plains to the east or across the cultivated fields to the west.

Today Utrecht is integrated into the Netherlands by modern forms of communication and transport (FIG. 2). The city is a thirty-minute ride on a fast train from Amsterdam and is an important railway junction for the Netherlands and Germany. In the seventeenth century, it was by no means cut off from the rest of the Dutch Republic: there was a regular system of passenger-carrying barges drawn by horses (known as *trekschuiten*) which linked all the principal towns. A *trekschuit* left Utrecht three times a day for the seven-hour trip to Amsterdam and the same number of times for Leiden, which was eight hours away. Utrecht was further from Amsterdam than Haarlem, Leiden, The Hague, Rotterdam or Dordrecht, which were tied more closely together not just geographically but economically and politically. Like other towns of the Dutch Republic, Utrecht possessed intense civic pride but it stood apart from the others because of the religious affiliations of its population, its social institutions and its political and economic situation.

The Dutch Republic had been born out of a religious struggle between Catholic Spain and the Protestant Netherlands. From the

beginning the political initiative had been taken by the Protestants, above all by the Calvinists. While the Calvinist Reformed Church was never the state church, it was immensely powerful, and Catholics were not permitted to worship in public in the Republic. Nonetheless, many Dutch citizens remained Catholic, practising their faith in private. The city of Utrecht had a long Catholic tradition. Saint Willibrord, one of the early missionaries who had converted the Netherlands to Christianity, made the city the seat of his bishopric in 690. (It became an archbishopric in 1559.) The cathedral was the largest in the Netherlands, and there were strong links with Rome. The only Dutch Pope, Adrian VI, came from Utrecht and he brought his own painter, Jan van Scorel, to Rome, where he succeeded Raphael as papal artist and curator of the Vatican art collection.

Catholicism remained a powerful force in Utrecht in the seventeenth century: it has been estimated that about thirty-five per cent of a population of 30,000 was Catholic. Utrecht was the centre of the Holland Mission, which attempted to win back the Netherlands for Catholicism. The Catholic clergy took courage from the example of Saint Willibrord to be zealous in the country's 'second conversion'. Philip Rovenius, the Pope's Apostolic Vicar, noted in 1616 that in Utrecht 'the leading and most distinguished inhabitants are for the most part Catholics, and about a third of the common people'.

1 Map showing the Dutch Republic in the seventeenth century

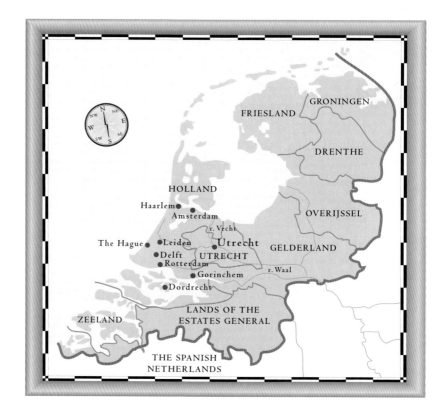

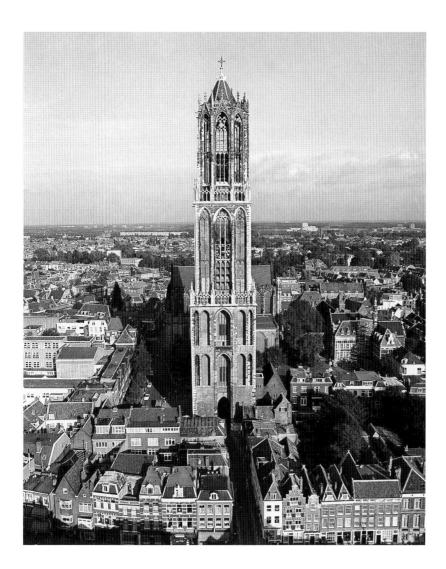

2 View of Utrecht today
showing the cathedral tower

However, perhaps the most significant aspect of Utrecht's religious
situation was its pluralism. In the late sixteenth century Utrecht
Protestantism was not as extreme in character as elsewhere in the North
Netherlands. In the early 1600s there was a prolonged and bitter struggle
within the Reformed Church: the Remonstrants were more liberal in both
doctrine and practice than the Contra-Remonstrants. This struggle between
the two factions soon assumed a political dimension, with the Regent,
or ruling, class of the great cities, led by Amsterdam, supporting the
Remonstrants, and the House of Orange backing the Contra-Remonstrants.
Eventually, the Contra-Remonstrants triumphed, and in 1619 the
Remonstrants were expelled from the Reformed Church and formed their
own congregations. Along with the Catholics, Lutherans and Mennonites,
they were gradually permitted to worship unhindered, at least in private.
The Remonstrants, Lutherans and Catholics all had *schuilkerken* (hidden

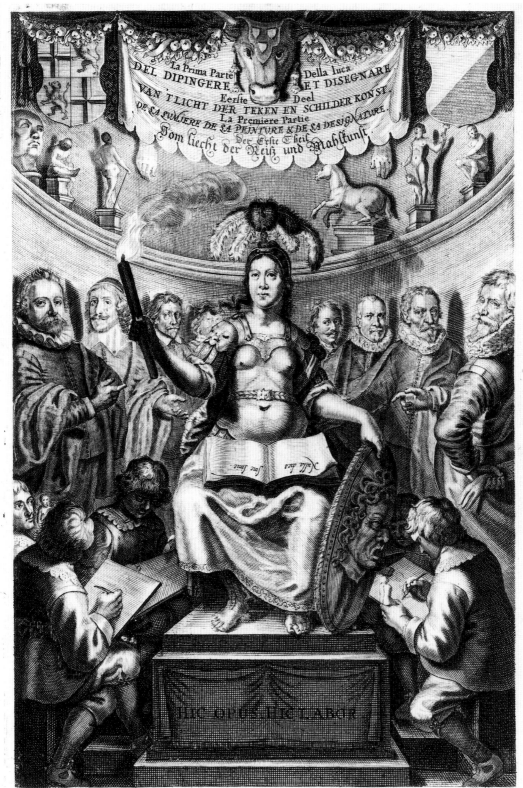

churches) in Utrecht. These were houses which on the outside looked like any other. Inside, however, they were churches and the Catholic *schuilkerken* were richly decorated and contained altarpieces commissioned from local artists. Their locations were well known to the city authorities, but their existence was often tolerated in the name of religious peace.

Utrecht's social and political structure was also unusual for the time. Although the town had enjoyed economic growth in the late sixteenth and early seventeenth centuries, it had not experienced the mass immigration from the south and the rapid industrialisation of the cities in the west. While the population of Amsterdam had grown from about 30,000 in the 1590s to 100,000 in the 1620s and 200,000 in the 1670s, Utrecht's had grown from 20,000 to 30,000 between 1580 and 1620 and then remained more or less constant throughout the century. The second largest city in the Netherlands at the end of the sixteenth century, Utrecht was overtaken during the 1600s by Leiden, Haarlem and Rotterdam. In Amsterdam, this process of rapid expansion had created a degree of social mobility that allowed the newly rich to marry into the Regent class and so exercise political power. To a greater or lesser extent this was also the pattern in the other towns of Holland. In Utrecht, however, the process of change was altogether more gentle. Those old families and rural aristocracy who converted to Protestantism succeeded in retaining power, continuing to play an important part in city and provincial government.

Utrecht did not, however, avoid the political and religious tensions of the Dutch Republic in its formative years: as in the other great cities of the Republic, 1618 saw the political triumph of the Contra-Remonstrants, the strict Calvinist wing of the Dutch Reformed Church which was allied to the House of Orange. This was the so-called *Alteratie*, or alteration, when Remonstrant city councils were dismissed and replaced by Contra-Remonstrants. In Utrecht two painters were directly involved in these events as supporters of the Contra-Remonstrant party. After the *Alteratie* Paulus Moreelse became a city councillor, followed some years later by Joachim Wtewael. In such a small community, these political changes had far-reaching effects: the Catholic Abraham Bloemaert was replaced by Moreelse as dean of the painters' guild and never again served in an official capacity.

Since the Middle Ages, the painters and sculptors of Utrecht had been members of the saddlers' guild, which had originally comprised all the artisans who were involved in making everything needed to equip a knight. By the mid-sixteenth century, painters and sculptors constituted more than half the guild membership of eighty-five. In the 1590s, there was pressure on the part of the younger generation of painters, including Abraham Bloemaert and Paulus Moreelse, to establish an independent

3 **Crispijn van de Passe**
title page of *Van 't Licht der teken en schilder konst*, second edition, 1664
The Hague, Koninklijke Bibliotheek

guild, but it was not until 1611, when Moreelse served as dean of the saddlers' guild, that the petition to the city council was successful. The new Guild of Saint Luke was given its charter on 13 September 1611. It had forty-four members, including nineteen painters, twelve decorative painters, thirteen sculptors and thirty-three apprentices. The first name on the list was that of Peter van Sijpenesse, the eldest son of Jan van Scorel, who symbolised the continuity of the Utrecht tradition. The destruction of the guild records makes it difficult to trace the organisation's fortunes in any detail, but it seems that the number of painters grew until the 1640s and then began to decline. There seem to have been between fifty and sixty master painters active in the city in the early 1640s. In 1639, the painters left the guild and petitioned to set up a 'Painters' College', a request which was finally granted in 1644. This was part of a movement by artists throughout the Republic to break away from the craftsmen's guilds and form societies which were more fitting for their dignified status. In practice, however, the Utrecht College operated as a guild, setting standards, supervising apprenticeships and arranging sales and auctions.

Most of the Utrecht masters had a few apprentices, but certain of them, who were renowned as teachers, had many pupils. Abraham Bloemaert had numerous apprentices during his long career, and both Paulus Moreelse and Gerard van Honthorst were also active teachers. In the mid-1620s, Honthorst was charging his pupils one hundred guilders a year; Jan van Bijlert was asking eighty-four guilders, Bloemaert and Nicolaus Knüpfer seventy-two. Since only relatively well-off parents could afford to have their sons apprenticed as artists and pay for the cost of a trip to Italy at the end of their training, painters for the most part came from the more prosperous sections of Dutch society. Apprentices would begin with menial tasks like the preparation of brushes and the application of grounds to panels and canvases, but would eventually assist their masters in the blocking-in of their compositions and even with entire sections of large paintings. They would also draw from casts and make drawn and painted copies of the master's work. Certain artists, notably Joost Cornelisz. Droochsloot and Adam Willaerts, specialised in teaching drawing.

In 1612, shortly after the creation of the Guild of Saint Luke, two of its leading members, Bloemaert and Moreelse, founded the Utrecht 'Academy'. The exact nature of this institution, based on the Italian model, is unclear, but we know that both established painters and apprentices were admitted upon payment of a fee, to draw from life. The leading painters of Utrecht – Bloemaert, Honthorst, Jan van Bronchorst, Roelandt Savery, Wtewael and Moreelse – can all be seen in Utrecht's 'renowned drawing school' in a print of 1643 by Crispijn van de Passe (FIG. 3).

2 Artistic Precursors

Utrecht was distinct from the rest of the Dutch Republic in the seventeenth century because of its geographical position, its loyalty to the old religion, and its political, social and economic structures. It is hardly surprising, therefore, that its rich artistic tradition was also quite independent.

Jan van Scorel (1495-1562) was a profoundly religious man, a canon of the Chapter of St Mary and a pilgrim to the Holy Land. His treatments of religious subjects, with their noble and powerful figures, are marked by intense sympathy and understanding. Scorel was greatly influenced by Italian painting, particularly the works of Raphael and his school, which he had studied in the engravings of Marcantonio Raimondi before being summoned by Pope Adrian to Rome, where he was able to study the originals. However, the landscapes in which his great religious dramas are set belong to a well-established Northern tradition of distant vistas rendered in layers of brown for the foreground, green for the middle ground and blue for the distance. Scorel was also an outstanding portrait painter, as can be seen in the powerfully individualised heads of the Jerusalem pilgrims which he painted in 1527-9 and include his self portrait (FIG. 4).

After the early death of Adrian VI, Scorel returned to Utrecht, where he spent the rest of his life supervising a large workshop producing altarpieces for churches and abbeys in the Netherlands. His most outstanding pupil was the portrait painter Anthonis Mor (c.1516/20-1575/6), who left Utrecht to enjoy an immensely successful career as court painter in Brussels and Madrid to the Habsburg Emperors, Charles V and Philip II.

Anthonie van Blocklandt (1533/4-1583) had trained in Antwerp with Frans Floris. He is mentioned in Utrecht in 1572, but shortly afterwards travelled to Italy and did not join the saddlers' guild until 1577. Blocklandt combined the figure style of his master with the

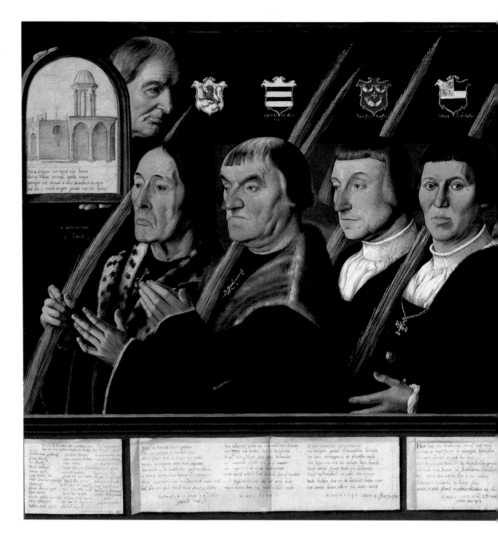

4 Jan van Scorel
Group Portrait of the Knightly Brotherhood of the Holy Land at Haarlem, 1527-9
Oil on panel, 114.5 x 276 cm
Haarlem, Frans Halsmuseum

refinement of Parmigianino, Salviati and Vasari, whose work he had studied in Italy. He produced large religious and mythological paintings whose style evolved in the direction of Mannerist refinement and exaggeration. Blocklandt was to exercise an important influence on the next generation of painters, including Hendrick Goltzius in Haarlem and Abraham Bloemaert in Utrecht, who developed a full-blown Mannerist style.

The Reformation meant an end to the principal source of patronage for artists, the painting of large-scale altarpieces for churches. The churches of Utrecht were emptied of their altarpieces, their interiors whitewashed and made over to Protestant worship. However, the Catholic community continued to commission religious paintings for the *schuilkerken* and for private devotion. In the first half of the century, the Catholic clergy demonstrated a clear preference for subjects showing conversion and miracles bringing sudden insight. A surprising proportion of artists' work was made up of religious paintings. It has been estimated that Bloemaert

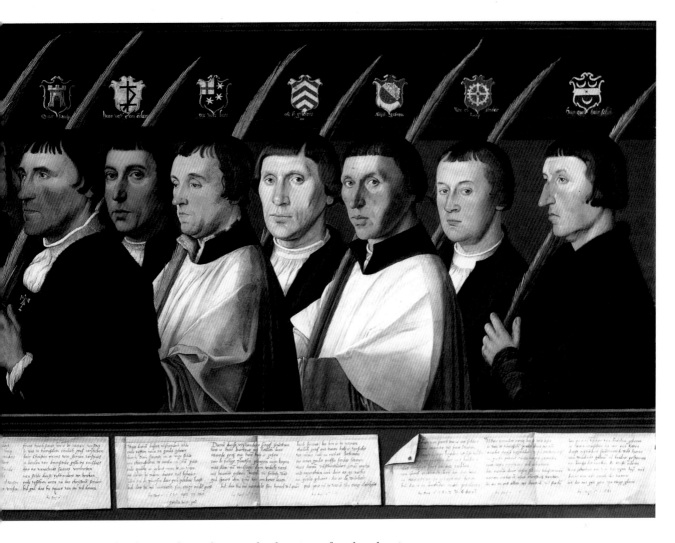

painted at least eighteen large-scale altarpieces for churches in
's Hertogenbosch, Brussels and The Hague, as well as in Utrecht.
Although the demand for religious paintings was greater in Utrecht
than in other centres, there was a gradual move towards subjects
from mythology and literature and genre scenes. Gerard van Honthorst,
for example, had achieved great success in Rome with large-scale
religious paintings, but seems to have received few such commissions
after his return to Utrecht. Unsurprisingly, he gradually turned to genre
subjects and portraiture.

Whatever the artists' own religious affiliations – Bloemaert was
a Catholic, Wtewael a Calvinist, for example – this seems, surprisingly,
to have had little effect on the subject-matter they depicted. Most
Protestant artists seem to have had no qualms painting Catholic subjects
if commissioned to do so.

3 The Mannerists: Abraham Bloemaert and Joachim Wtewael

Mannerism was an international style of the sixteenth century, practised in Fontainebleau and Prague as well as in Florence and Rome, which placed great emphasis on elegance and refinement. It was highly stylised, rejoicing in complex poses and rich detail. In Utrecht, the key figures in the development of this style around 1600 were Abraham Bloemaert and Joachim Wtewael.

Bloemaert (1566-1651) was a pupil of his father, Cornelis, a sculptor and architect, and of the painter Joos de Beer. The single most important figure in painting in Utrecht during the seventeenth century, Bloemaert was responsible for the training of successive generations of Utrecht painters during his very long life. Among his pupils were Hendrick ter Brugghen, Gerard van Honthorst, Cornelis van Poelenburgh, Jan van Bijlert, Jan and Andries Both, and Jan Baptist Weenix. He also attracted pupils from outside Utrecht: Wybrand de Geest came from Leeuwarden, Jacob Gerritsz. Cuyp from Dordrecht and Nicolaus Knüpfer from Leipzig. Abraham's son, Frederick, who was an engraver, published the *Tekenboek* (Drawing Book) in the early 1650s, a volume made up of 166 prints after designs by his father and intended for young artists. The elder Bloemaert was remarkably open to new artistic currents, successively adopting Mannerist, Caravaggesque and classicising styles in response to new ideas, many of them brought back by his pupils from their stays in Italy.

Since early in the sixteenth century it had been usual for Netherlandish artists to complete their training with a trip to Italy to study the Antique and High Renaissance art. Bloemaert had spent his travel years not in Italy but in Paris, where he had worked in the studio of Hieronymous Franck. The most powerful influence on his early work, however, came not from France but from the court in Prague where Bartholomeus Spranger's highly elaborate, complicated and even contorted figure style was admired by Emperor Rudolf II. Born in Antwerp, Spranger had worked in Italy, most notably on the decoration of the Farnese villa at Caprarola with the arch-

Detail of figure 7
Joachim Wtewael
The Judgement of Paris, 1615

5 Nicolaus Knüpfer
*Brothel Scene, c.*1650
Oil on panel, 60 x 74.5 cm
Amsterdam, Rijksmuseum

Mannerists Federigo and Taddeo Zuccaro. Spranger's complex and crowded compositions were known in the Netherlands in the form of engravings made after his designs, and his idiosyncratic Mannerism had attracted the attention of the Haarlem artists Carel van Mander, Hendrick Goltzius and Cornelis van Haarlem. Goltzius had made prints after Spranger, notably the large engraving on three plates entitled *The Wedding Feast of Cupid and Psyche* (1587), which was widely circulated and admired. Bloemaert's earliest paintings such as *The Marriage of Cupid and Psyche* (*c.*1595: London, Royal Collection) and *Moses Striking the Rock* (1596: FIG. 6) are in this tortured, highly mannered style, which was also in demand among collectors in Utrecht. In *Moses Striking the Rock*, the figures adopt exaggerated poses and the draperies are agitated. The subject of the painting – the bearded prophet striking his stick against the rock to produce a gushing stream – is hidden away in the shadows on the left, and the viewer's attention is seized by the elaborately posed, half-naked figure of a girl who holds a golden ewer on her shoulders. Her skin is strikingly white and

her dress is gathered to emphasise her naked breasts and legs. The nudes in the foreground on the left and in the background on the right are very closely modelled on those of Cornelis van Haarlem, whose work in a Sprangerian style Bloemaert must have known. It is an extraordinary phenomenon in the transfer of styles that Rudolf II's highly refined and erotic court art should have taken such strong root in the Dutch cities of Haarlem and Utrecht.

In Bloemaert's long career, Sprangerian Mannerism was a relatively short phase – all his paintings in this style were made between 1590 and 1600 – but his Utrecht contemporary, Joachim Wtewael (1566-1638), continued to paint in this manner throughout his working life. A native of Utrecht, Wtewael had been trained in the workshop of his father, the glass painter Anthonis. Joachim's travel years were spent in Italy and France; between 1588 and 1590, he was in the service of the Bishop of St Malo. After his return to Utrecht, Wtewael not only set up a studio but also began to trade in flax, which made him less dependent on painting for his income. His style is a highly individual fusion of the School of Fontainebleau, the Mannerism of the Zuccari and the Rudolfine court style, as seen through the prints of Goltzius and paintings of Cornelis van Haarlem. Wtewael painted on both a small, almost miniaturist scale and life-size. In his small pictures the paint stands up from the flat surfaces of copper or oak panels in elaborate swirls. These are precious works, similar in effect to finely worked enamels, which were presumably held in the hand by their owners and admired for the intricacy of design and richness of detail. The *Wedding of Peleus and Thetis* (1612: Williamstown, Clark Art Institute) and *Mars and Venus disovered by Vulcan* (1601: The Hague, Mauritshuis) are outstanding examples of his work. In *The Judgement of Paris* (1615: FIG. 7), painted on oak on a slightly larger scale, Wtewael combined two distinct scenes in the story told in Ovid's *Metamorphoses* of the beginning of the Trojan War. In the background on the right, painted in glistening white highlights, is the marriage of Peleus and Thetis to which Eris, the personification of strife, can be seen bringing the apple which provoked a quarrel between the goddesses as to who was the fairest. Mercury then brought Venus, Juno and Minerva to the shepherd Paris on Mount Ida to judge between them. Paris's choice of Venus and her granting of Helen to Paris was to lead to war. In Wtewael's composition, the three goddesses and the seated Paris adopt complex poses which permitted the artist to display his virtuosity in anatomy and foreshortening. The panel is crowded with detail: the goats, Paris's dog, the camel in the distance, the putti who crown Venus, the river god and his companion and the ornate shells in the foreground. Wtewael's technical mastery of oil paint is truly astonishing.

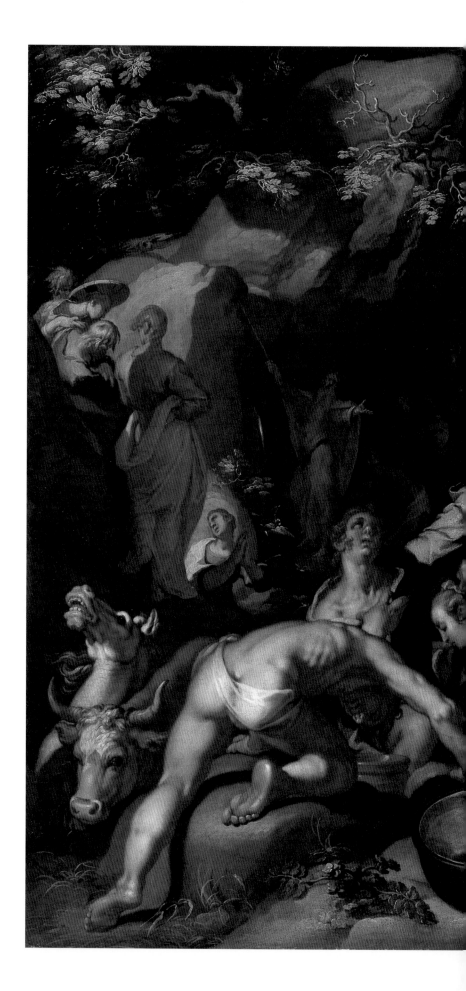

6 **Abraham Bloemaert**
Moses Striking the Rock, 1596
Oil on canvas, 80 x 108 cm
New York, Metropolitan
Museum of Art

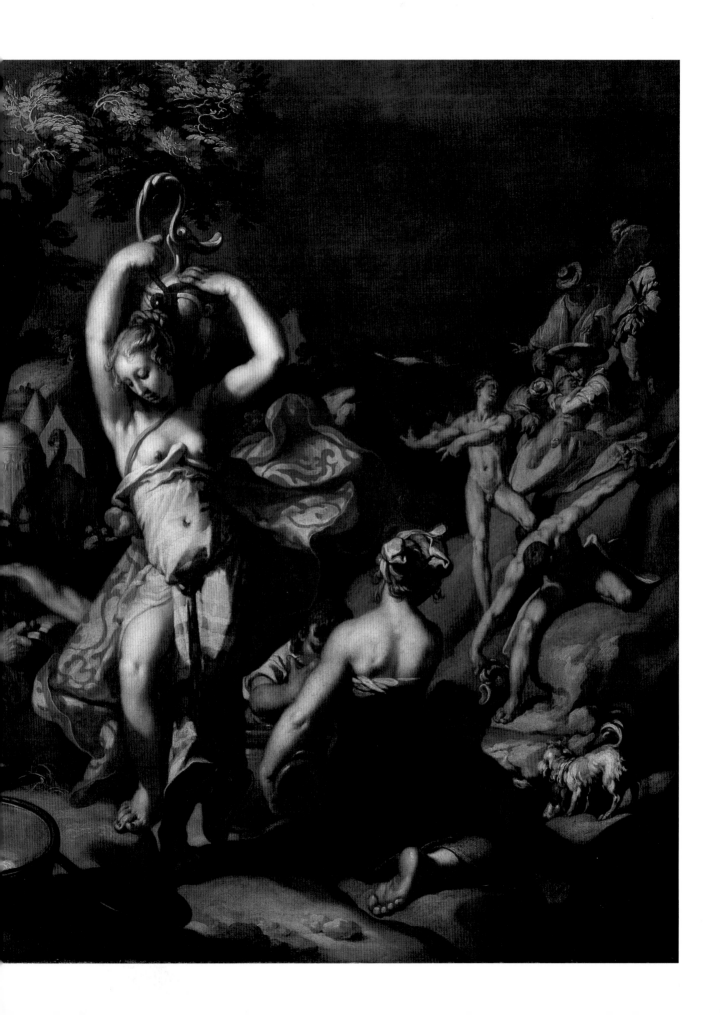

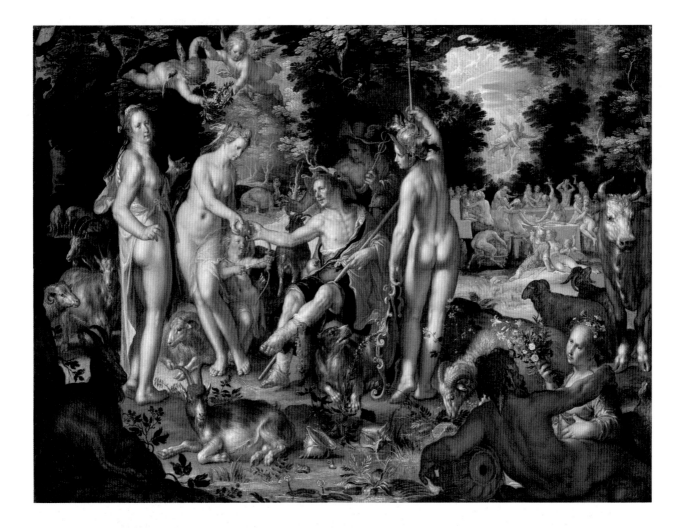

7 **Joachim Wtewael**
The Judgement of Paris, 1615
Oil on panel, 59.8 x 79.2 cm
London, National Gallery

OPPOSITE
8 **Joachim Wtewael**
Saint Sebastian, 1600
Oil on canvas, 169.2 x 125.1 cm
Kansas City, The Nelson-Atkins
Museum of Art

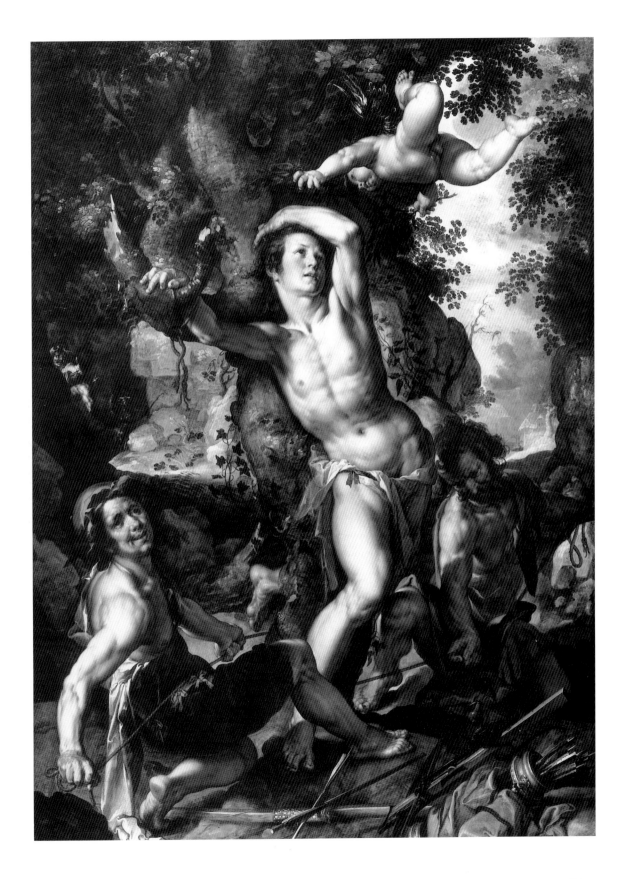

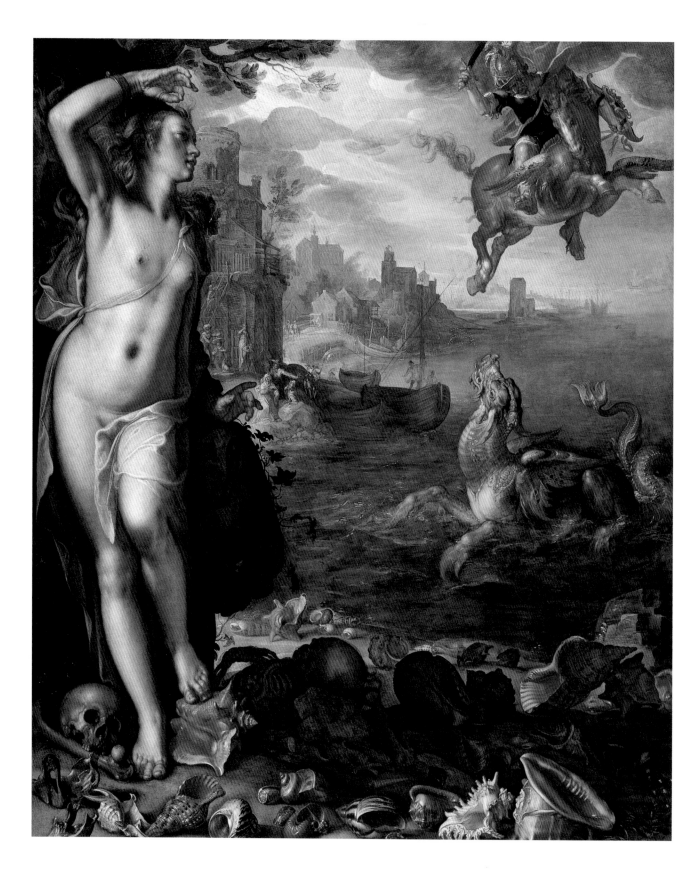

As well as these jewel-like works, Wtewael painted large canvases
such as *Saint Sebastian* (1600: FIG. 8) and *Andromeda* (1611: FIG. 9). His
technical gifts are no less evident in these life-size works. Saint Sebastian
is shown being bound to a tree before the archers take aim. His heavily
muscled body twists in a pose so complicated that his left foot can be
seen emerging from behind the tree. The men who tie him adopt equally
elaborate poses, the one on the left leaning back on his left leg as he pulls
the rope tight, and the second, in the shadows on the right, splaying his
legs and extending his left arm. Sebastian's body is modelled in deep red
shadows and white highlights. He raises his eyes to an angel who brings
laurel to crown him. The composition is crowded with detail: there is a
fine still life of crossbow and quiver in the foreground and two landscape
vistas beyond. Another archer hurries to the scene on the left.

Andromeda is similarly dominated by a full-length nude, although
her pose is far more natural. She turns her head towards the sea where
her fate is being decided, as Perseus descends on his winged horse to kill
the exotic sea-dragon. Andromeda's skin gleams silver as she stands on the
sand amidst a remarkable collection of exquisitely painted shells. Shells
were highly sought after by collectors in the Netherlands, and so promi-
nent and precisely described are these examples that it is possible that the
painting was a commission from a shell collector. Wtewael must have had
a group of patrons who admired his dexterity and demanded that he con-
tinue to paint in this elaborate manner. Through successive waves of
Caravaggism and classicism in Utrecht, Wtewael merely toned down some
of his wilder excesses. By the time of his death in 1638, his style must
have seemed very old-fashioned. Wtewael became wealthy, probably as a
result of result of his trading in flax. He owned substantial property in the
town, became a prominent local figure, and served as a town councillor.

Paulus Moreelse (1571-1638) was a slightly younger contemporary
of Bloemaert and Wtewael. He was a native of Utrecht who had trained
as a portrait painter with the Delft portraitist Michiel Mierevelt (himself
a pupil of Blocklandt in Utrecht). Moreelse achieved great local fame for
his portraits such as that of Dirck Strick (1625: Allentown, Art Museum),
which are more robust, fleshy and three-dimensional than those of his
master. Like Wtewael, he was a prominent local figure, who was a member
of the Contra-Remonstrant party, and served as a member of the city
government and as dean of the painters' guild.

9 **Joachim Wtewael**
Andromeda, 1611
Oil on canvas, 180 x 150 cm
Paris, Musée du Louvre

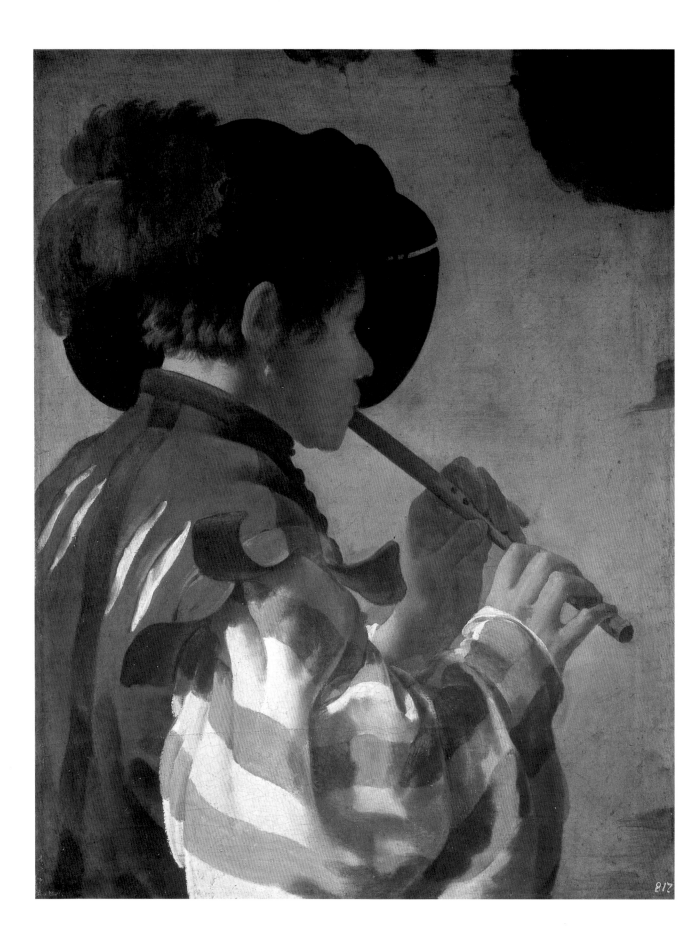

4 The Caravaggesque Painters

Four young painters from Utrecht, pupils of Bloemaert and Moreelse, went to Rome around 1610 and brought back a style which transformed Utrecht painting – the style of Caravaggio. As we have seen, the practice of making a study tour outside the Netherlands after completing their apprenticeships had been quite usual among earlier generations of Utrecht painters. Their destination had usually been Italy, although late in the sixteenth century some travelled to France, drawn by the fame of the School of Fontainebleau. In the early years of the seventeenth century, young artists from all over Europe flocked to Rome, not just to study the treasures of the Antique and the High Renaissance, but to see the exciting developments in contemporary painting. Annibale and Agostino Carracci had brought their new Bolognese classicism to the city and had created the breathtaking frescoed ceiling of the Palazzo Farnese. Their cousin Ludovico's pupil, Domenichino, had arrived in the city and was working for Cardinal Aldobrandini. Guido Reni was there too, working for Pope Paul V and Cardinal Scipione Borghese: he had completed the *Aurora* fresco in the Cardinal's Casino by 1614. It was a time of hectic activity and experimentation.

The young painters from Utrecht studied the work of all these artists, but there was one who was to have by far the greatest effect on them. Despite Caravaggio's relatively short stay in the city – he had arrived in 1592 and had to leave after killing a man in 1606 – he had a massive impact on painting in Rome. He had decorated the Contarelli Chapel in S. Luigi dei Francesi with scenes from the life of Saint Matthew which were so radical in conception that they had delighted and offended viewers in equal measure. His dramatic scenes from the lives of Saints Peter and Paul could be seen in the Cerasi Chapel in Sta Maria del Popolo, and more of his work could be found in the collections of Cardinals del Monte and Scipione Borghese. A modern spectator looking at Caravaggio's work is immediately struck by his use of chiaroscuro – the contrast of

15 **Hendrick ter Brugghen**
Flute Player, 1621
Oil on canvas, 70 x 55 cm
Kassel, Staatliche Museen

light and shadow – which he employed in order to heighten the dramatic power of a scene. However, if we read the reactions of contemporaries to Caravaggio's paintings, it is clear that it was not this technical device as much as his realistic treatment of sacred subjects that impressed – and in some cases horrified – them. Carel van Mander wrote that Caravaggio 'does not execute a single brush stroke without taking it directly from the life'. The young Dutch painters, schooled in artificiality and pattern-making, were mesmerised by this new, naturalistic style. Although Caravaggio does not seem to have had any pupils, his influence was enormous.

The four Utrecht painters who travelled to Rome – Dirck van Baburen (c.1595-1624), Hendrick ter Brugghen (1588-1629), Gerard van Honthorst (1592-1656) and Jan van Bijlert (1597/8-1671) – were all transformed by what they saw there. This transformation of a generation of young Utrecht painters by their encounter with Caravaggio in Rome was a defining moment in the history of the Utrecht school. Many Dutch artists went to Rome and were influenced by what they saw – Pieter Lastman, Rembrandt's teacher, for example, was among them – but none were as intensely responsive as those from Utrecht. The close links between painting in Utrecht and Rome and the particular demands of Utrecht patrons for religious paintings go some way to explain this phenomenon, but it must equally have been the consequence of personal aesthetic responses to the work of Caravaggio. It is interesting to compare these young painters with Rembrandt, who was born a decade or so later in Leiden. Urged by Lastman and others to travel to Italy when he had completed his training, Rembrandt instead set up a studio in Leiden and began to work independently. He is reported to have said that he was so busy that he had no time to go to Italy, and besides, all the best Italian paintings were in the Netherlands. For Rembrandt, as for many Dutch painters, Caravaggio's was one of a large number of artistic influences. For the Utrecht painters the encounter with his work in Rome proved overwhelming.

The greatest of these four Utrecht painters was Hendrick ter Brugghen. Probably born in The Hague, he had had his early training in Bloemaert's Utrecht workshop. It is not entirely clear when ter Brugghen set out for Italy, but he was back in 1614 and was said to have been there for ten years. He was certainly the first to return from Rome to Utrecht carrying the gospel according to Caravaggio. Ter Brugghen adopted the chiaroscuro, realism and monumental compositions of Caravaggio and his followers. His *Calling of Saint Matthew* (1621: FIG. 10), for example, is an interpretation of Caravaggio's great canvas of the same subject in S. Luigi dei Francesi. Ter Brugghen concentrated the focus of the picture, moving from Caravaggio's spacious composition with full-length figures to a

crowded half-length scene, with Christ's pointing finger stabbing directly
at Matthew's chest. The space is very shallow and even claustrophobic,
but the drama remains intense. To this reworking of Caravaggio's
composition ter Brugghen brought his own remarkable palette of near-
pastel colours and a highly original treatment of contrasting textures.

Ter Brugghen also drew upon his familiarity with earlier
Netherlandish models: an example is the strikingly archaic *Crucifixion
with the Virgin and Saint John* (*c*.1625: New York, Metropolitan Museum
of Art), in which the simple three-figured composition is outlined against
a sky dotted with gold stars. The commission may have been intended to
replace a fifteenth- or sixteenth-century altarpiece. The emaciated body
of Christ slumps on the cross, bending at the knees and bleeding heavily,
while the Virgin and Saint John gaze in pitiful adoration. In his highly
personal style, ter Brugghen created some of the greatest religious
masterpieces of Dutch seventeenth-century painting. In *Christ crowned
with Thorns* (1620: FIG. 11), the Saviour bows his head before the taunts
and blows of his mockers, while in the background the Jewish priests

10 Hendrick ter Brugghen
Calling of Saint Matthew, 1621
Oil on canvas, 102 x 137 cm
Utrecht, Centraal Museum

demand that Pilate sentence him to death. Christ is the calm centre of a composition of agitation and violence. Ter Brugghen loved the rich elaboration of folds: every sleeve, scarf, robe and turban falls in intricate patterns, creating complicated shadows. His tender *Annunciation* (FIG. 12), painted in 1629, was presumably commissioned by a Catholic patron to hang above an altar, perhaps in one of the city's *schuilkerken*. The archangel towers above the childish figure of Mary, who modestly lowers her eyes and crosses her hands over her chest, accepting her fate with humility.

Ter Brugghen's greatest religious work is, however, the profoundly moving *Saint Sebastian Attended by Saint Irene* (1625: FIG. 13). Sebastian is slumped, his head almost touching his knees, the muscles of his arm, his ribs and his legs modelled by soft shadows. As her attendant releases the bonds on his wrist, Saint Irene slowly draws out an arrow from his side with intense concentration and delicacy. The whole scene is set against a sky suffused with the colours of the setting sun.

It was not only the religious elements in the work of Caravaggio and his followers that ter Brugghen and the other young Utrecht painters admired. They borrowed individual figures, such as the fashionably dressed young men who occupy prominent positions in Caravaggio's *Calling of Saint Matthew* and their counterparts in his secular paintings. Ter Brugghen isolated such figures, giving them musical instruments and wine glasses and placing them at an open window or behind a balustrade looking directly at the spectator. In so doing, he also lightened Caravaggio's sombre palette. Ter Brugghen's masterpiece in this secular manner is *The Concert* (FIG. 14), in which he placed three half-length musicians in shallow space around a flickering candle. He brought to this composition a striking fluency in the modelling of soft edges and a remarkable subtlety of palette, including light blues, lemon, purple and cerise. Among the single figures in this style are the delicate *Flute Player* (1621: FIG. 15) – seen teasingly from the side, his features outlined against his black hat, his billowing, striped sleeve creating elaborate patterns of light and shade – *A Man Playing a Lute* (1624: London, National Gallery) and *Singing Girl* (1628: Basel, Kunstmuseum). In *Melancholia* (1627-8: FIG. 16), ter Brugghen used the single-figure format to create a composition of great gravity. The woman, who could equally be the Magdalen, holds a skull in the flickering candlelight: the soft shadows create a mood of melancholy contemplation, a profound meditation upon mortality and human folly.

We know nothing about any paintings made by ter Brugghen in Italy, but Dirck van Baburen, who had been a pupil of Moreelse in Utrecht, received at least one important commission in Rome, for the decoration (with David de Haen) of a chapel in S. Pietro in Montorio. The altarpiece, *The Entombment*, painted in 1617, is based on Caravaggio's

11 **Hendrick ter Brugghen**
Christ crowned with Thorns, 1620
Oil on canvas, 207 x 240 cm
Copenhagen, Statens Museum
for Kunst

famous treatment of the subject, which during Baburen's stay in Rome
hung in the Chiesa Nuova. Baburen returned to Utrecht around 1621 and
formed a working relationship with ter Brugghen; they may have shared a
studio.

In *Prometheus chained* (FIG. 17), which dates from 1623, Baburen,
shortly after his return from Rome, chose to represent the moment when
Prometheus was chained to a rock by Vulcan rather than the more usual
scene showing the Titan's liver being pecked at by an eagle (which had
been painted, for example, by Rubens). The eagle hovers, awaiting its
chance, in the top left-hand corner. This is Baburen's most completely
Caravaggesque work, with the near-naked bodies of Vulcan and Prometheus
illuminated by a powerful fall of light so that they emerge from the
surrounding darkness. Prometheus bellows in rage, while Mercury grins
mischievously and assists Vulcan with the manacles.

In his *Mocking of Christ* (FIG. 18), Baburen used the half-length
'close-up' format, concentrating the viewer's attention on the head of
Christ at the centre. His modelling, unlike ter Brugghen's, is in flat planes
of colour, the folds of drapery jagged rather than flowing. This work is
more consciously composed than ter Brugghen's great canvas and lacks
real pathos, yet it is highly dramatic, with the three central heads harshly
illuminated by a strong fall of sunlight.

Like ter Brugghen, Baburen adapted Caravaggio's half-length figures

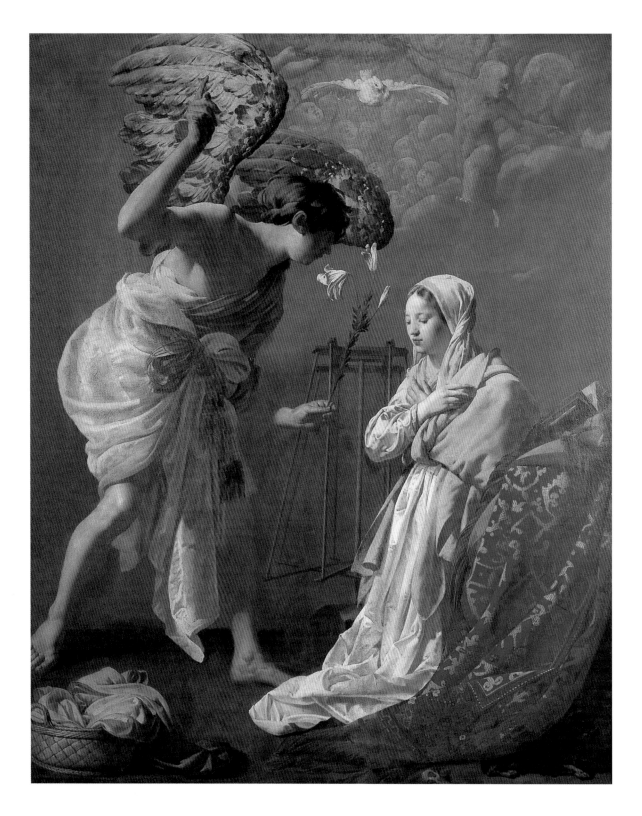

12 **Hendrick ter Brugghen**
The Annunciation, 1629
Oil on canvas, 216.5 x 176.5 cm
Diest, Stedelijk Museum

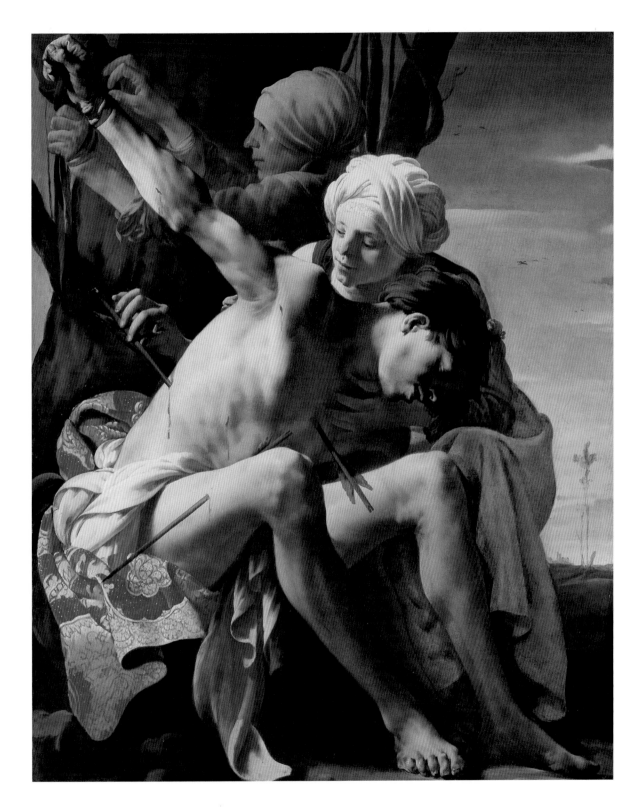

13 **Hendrick ter Brugghen**
Saint Sebastian Attended by Saint Irene, 1625
Oil on canvas, 175 x 120 cm
Oberlin, Allen Memorial Art Museum

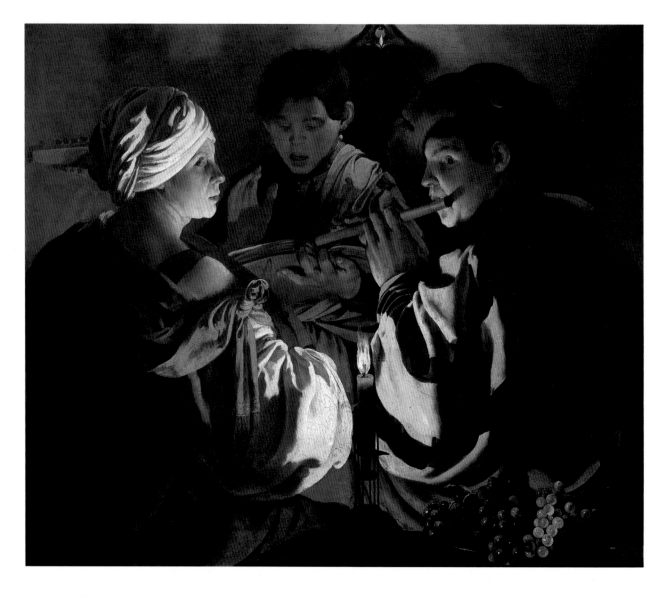

14 **Hendrick ter Brugghen**
The Concert, *c.*1626
Oil on canvas, 99.1 x 116.8 cm
London, National Gallery

OPPOSITE
16. **Hendrick ter Brugghen**
Melancholia, 1627-8
Oil on canvas, 67 x 46 cm
Toronto, Art Gallery of Ontario

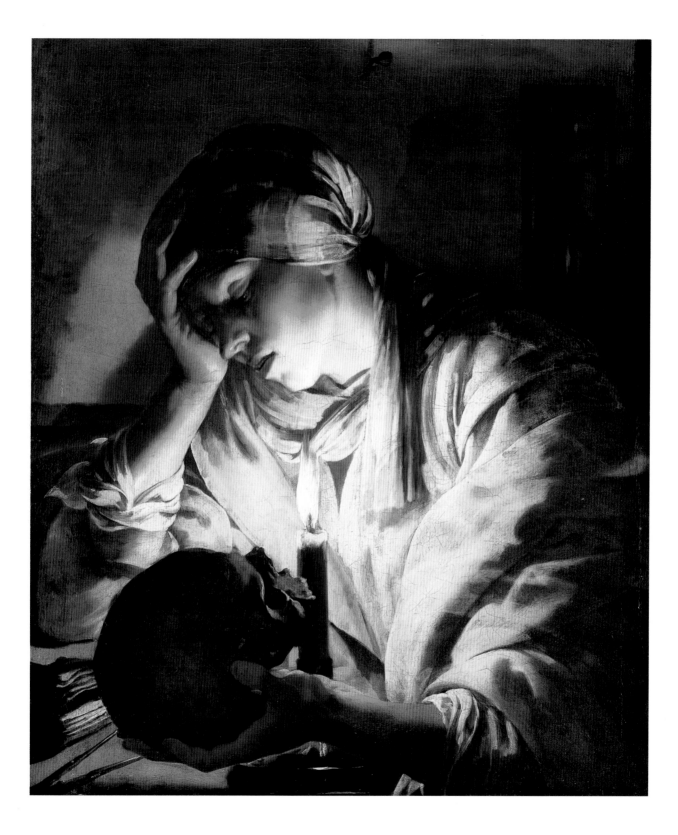

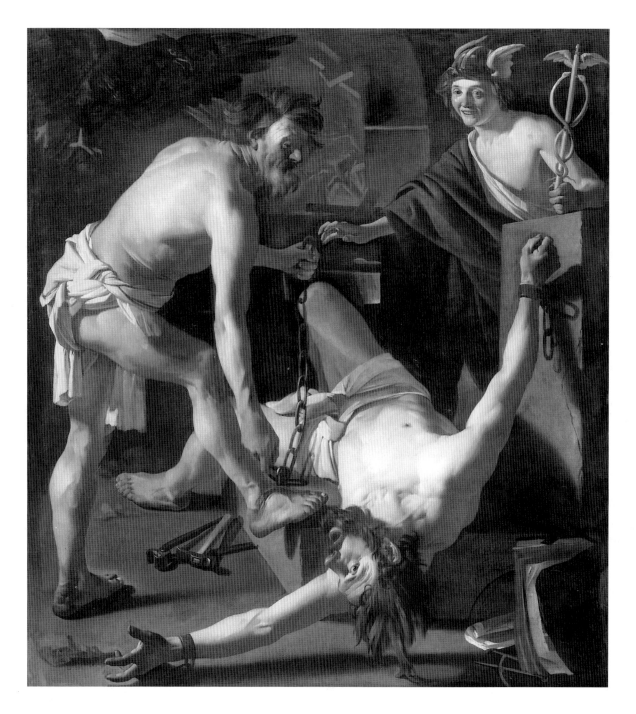

17 **Dirck van Baburen**
Prometheus chained, 1623
Oil on canvas, 202 x 184 cm
Amsterdam, Rijksmuseum

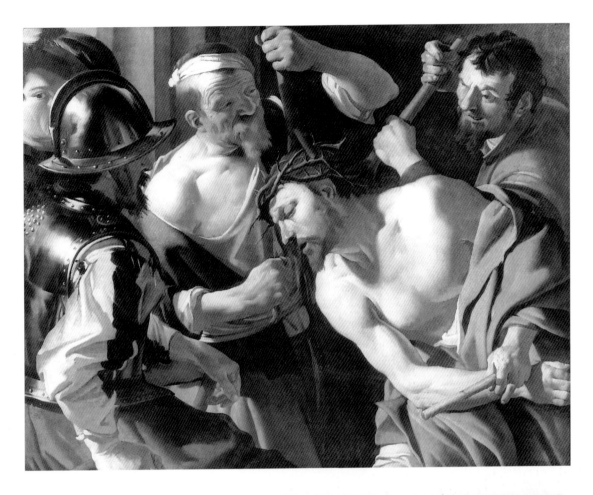

18 Dirck van Baburen
The Mocking of Christ, 1621-2
Oil on canvas, 106 x 136 cm
Utrecht, Museum Catharijneconvent

19 Dirck van Baburen
The Procuress, 1622
Oil on canvas, 101 x 107.3 cm
Boston, Museum of Fine Arts

to secular subject-matter in paintings like *The Procuress* (FIG. 19) and *Young Man playing a Jew's Harp* (1621: Utrecht, Centraal Museum). In *The Procuress*, Baburen placed his three half-length protagonists in a shallow space, balancing the amorous couple with the old procuress demanding payment for the young girl's favours. The composition is similar to ter Brugghen's *Concert* but the light, falling from the left, is more even and the modelling harder and more linear. Particularly effective is the way in which the light passes through the girl's fingers, throwing a pattern on the lute. The painting, or a copy of it, seems to have been owned by Jan Vermeer, as it appears hanging on the back wall of two of his interior scenes. Vermeer was an art dealer as well as a painter and could well have had the picture as part of his stock.

Although Baburen died only three years after his return to Utrecht, he had already established a formidable reputation. He is particularly important as a creator of new subject-matter: he was the first Dutch painter to paint Saint Sebastian attended by Saint Irene and also the first

21 **Gerard van Honthorst**
Denial of Saint Peter, c.1620-5
Oil on canvas,
110.5 x 144.8 cm
The Minneapolis Institute
of Arts

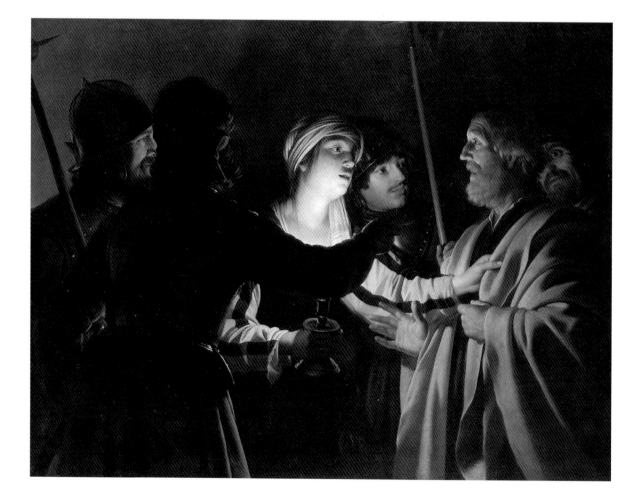

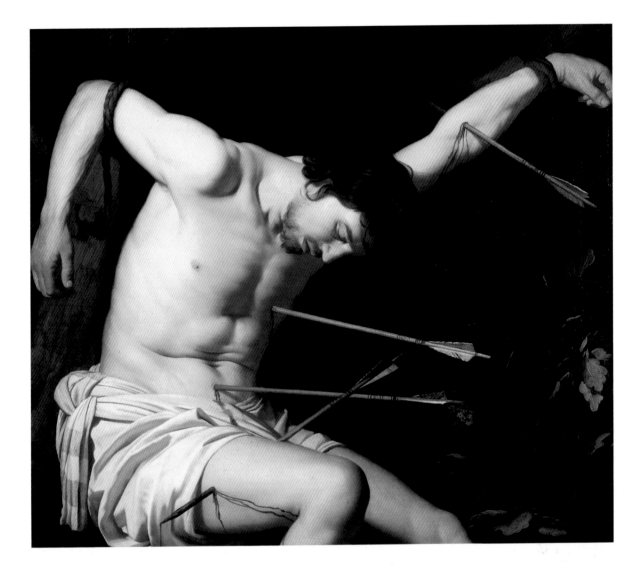

to illustrate *Granida and Daifilo*, a popular arcadian play by Pieter Cornelisz. Hooft. When in about 1629 the influential Constantijn Huygens, secretary and artistic adviser to the Prince of Orange, made a list of the leading Netherlandish history painters of recent years, he included Baburen along with Bloemaert, ter Brugghen and Gerard van Honthorst.

Honthorst, a pupil of Bloemaert, arrived back in Utrecht from Rome in 1620. He was welcomed home at a special dinner held at the inn 'Het Poortgen' that summer and attended by his master, Moreelse and the engraver Crispijn van de Passe. By then, Honthorst had a well-established reputation in Rome, where he was known as 'Gherardo della Notte' for his widely admired candlelit scenes. He had worked for a number of prominent Roman patrons, including the Marchese Vincenzo Giustiniani, for whom he painted *Christ before the High Priest* (London, National

20 **Gerard van Honthorst**
Saint Sebastian, *c*.1623
Oil on canvas, 101 x 117 cm
London, National Gallery

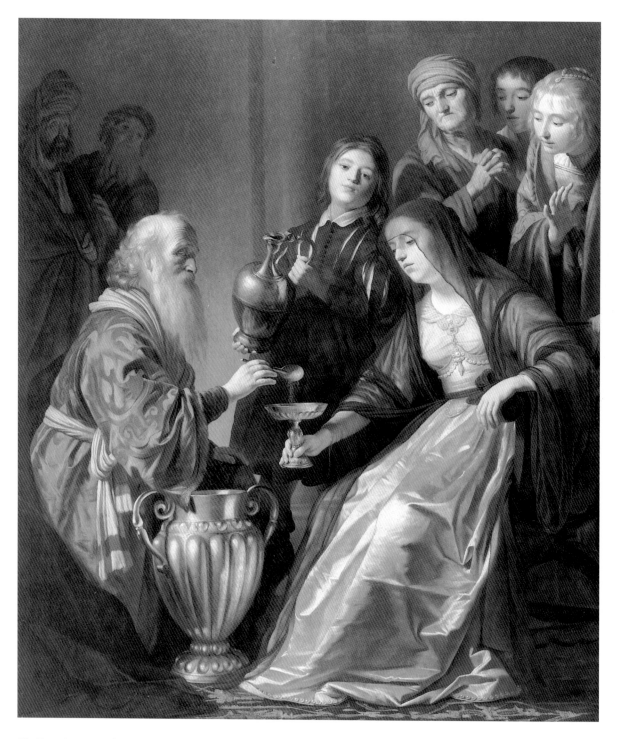

22 Gerard van Honthorst
Artemesia, 1632-5
Oil on canvas, 170 x 147.5 cm
Princeton, The Art Museum

23 **Jan van Bijlert**
*Alms Gatherers of the Saint
Job's Hospice*, c.1630-5
Oil on canvas, 76.3 x 115.3 cm
Utrecht, Centraal Museum

Gallery) around 1617. After his return, Honthorst established a truly international reputation, the only member of the Caravaggesque group to do so. He worked not only for the court in The Hague – where he gave drawing lessons to the children of Charles I's sister, Elizabeth Stuart, the 'Winter Queen' – but also for those in London and Copenhagen. Honthorst was in London in 1628-9 and painted a large-scale allegorical scene showing the Duke of Buckingham as Mercury leading the Liberal Arts to pay homage to the King as Apollo and the Queen as Diana. It hangs today at Hampton Court.

Honthorst's style gradually moved away from the Caravaggism of his early Utrecht years to a blander, classicising manner. This change can be seen by comparing *Saint Sebastian* (FIG. 20) and the *Denial of Saint Peter* (FIG. 21), both painted soon after his return from Rome, and *Artemisia* (FIG. 22), painted about ten years later. In *Saint Sebastian*, the saint's body is modelled by light, while the wounds made by the arrows are treated with an uncompromising naturalism. Blood soaks into his loincloth and drips from the protruding point of one of the arrows. In the *Denial of Saint Peter*, the face of the servant who identifies Peter as one of the followers of Christ is strongly illuminated by the candle she carries. Its flame is concealed from the viewer by the outstretched arm of a second accuser.

The bright light within the gloom heightens the drama of the scene. *Artemisia* shows a solemn rather than a highly dramatic moment. The widowed wife of Mausoleus is about to drink his ashes mixed with wine and so become a living mausoleum. The contrasts are softened, the forms more elaborately modelled and the figures arranged more spaciously within the composition. This was a highly appropriate subject for the decoration of the Huis ten Bosch, the summer palace outside The Hague which the widowed Amalia van Solms turned into a mausoleum for her husband, Prince Frederik Hendrik of Orange.

Honthorst was also much sought after as a portrait painter: he was the chosen portraitist of the House of Orange and their court and had a large studio, producing numerous replicas of his state portraits. Like his master Bloemaert, he was a very active teacher, running large studios in Utrecht and, later, in The Hague. According to his pupil Joachim von Sandrart, Honthorst had twenty-four or twenty-five pupils around 1625; each of them paid the master one hundred guilders a year for instruction.

The fourth member of this group of young Utrecht painters who travelled to Italy was Jan van Bijlert, who after returning to his native city in 1624 enjoyed a long and successful career as a painter of biblical and mythological subjects, genre paintings and portraits. Like Honthorst, Bijlert gradually abandoned the thorough-going Caravaggism he had brought back from Rome. In *Mary Magdalen turning from the World to Christ* (1630s: Greenville, Bob Jones University Museum and Gallery), painted some ten years after leaving Italy, he had already moved to a more classicising manner strongly influenced by Honthorst and the French painter Simon Vouet. Bijlert subsequently abandoned the half-length figure format of the Caravaggesque painters for full-length figures in carefully described interiors. An eclectic artist, he also worked in the style of Cornelis van Poelenburgh. In his remarkable group portrait of the *Alms Gatherers of the Saint Job's Hospice* (FIG. 23), the men are richly differentiated by pose and gesture; they are shown standing behind a parapet and in a curiously inappropriate Italian setting of a circular temple, cypresses and antique ruins.

The return of these young painters to Utrecht in the years after 1620 had the effect of reanimating the city's artistic life. Bloemaert was profoundly influenced by the Caravaggesque style of his returning pupils in works such as *The Adoration of the Magi* (FIG. 24) and *Amaryllis and Mirtillo* (1635: Berlin, Jagdschloss Grünewald). In *The Adoration of the Magi*, painted in 1624, the Virgin is powerfully Caravaggesque in inspiration, and the figure of Joseph is thrown into shadow by the overhanging roof of the stable. Balthasar and Caspar are also shown in shadow while the central encounter between the Christ Child and Melchior, the king who brought gold, is strongly lit. The lighting has the

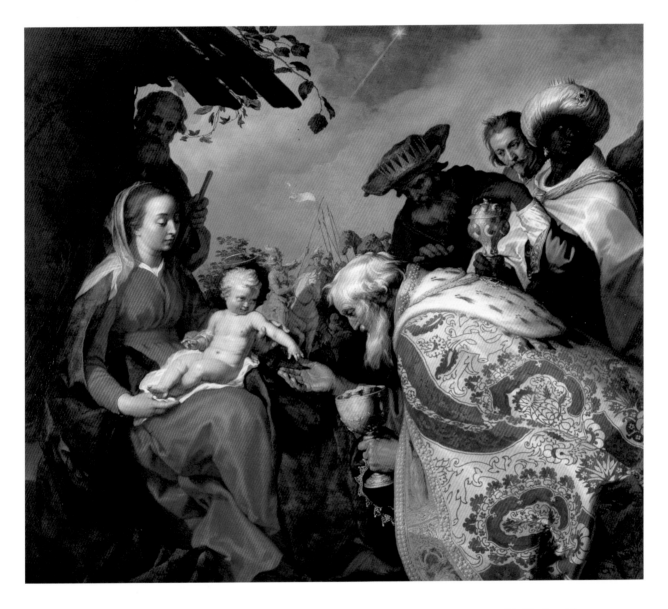

24 **Abraham Bloemaert**
Adoration of the Magi, 1624
Oil on canvas, 168.5 x 194 cm
Utrecht, Centraal Museum

effect of dramatising the encounter. Bloemaert was not, however, entirely dependent on Caravaggio; he was also very conscious of Rubens's vigorous and dramatic altarpieces. Rubens was an important model for artists throughout the Northern Netherlands. He visited Utrecht in July 1627 in the course of a diplomatic mission to the north and met Honthorst and other young painters. Sandrart tells us that

> as he subsequently wanted to visit Abraham Bloemaert,
> Cornelis Poelenburgh and others, but could not be
> accompanied by Honthorst who was unwell, he desired
> that I be sent with him, and indeed I then showed him
> everything to his great satisfaction... During this journey
> he praised highly, among others, Honthorst's perfect
> manner of painting, especially the nocturnes, Bloemaert's
> noble draughtsmanship and Poelenburgh's intelligent,
> small figures.

Despite its importance, Caravaggism was a short-lived artistic phenomenon in Utrecht and by 1630 had lost much of its vitality. Ter Brugghen and Baburen were dead, while Honthorst had largely abandoned his Caravaggesque manner. Bijlert, too, had watered down his Caravaggism. Nonetheless, many of the greatest pictures made in Utrecht in the seventeenth century were painted by the young artists who had been inspired by what they had seen in Rome and created their own beautiful and effective interpretation of Caravaggio's style.

5 Italianate Landscape Painting: Cornelis van Poelenburgh and Jan Both

It was not just the painters of large-scale figure scenes who spent their study years in Italy. One of the most original and successful of all Utrecht painters in the first half of the seventeenth century was Bloemaert's pupil Cornelis van Poelenburgh (1594-1667), who travelled to Italy around 1617 and remained there for about eight years. In Rome, he studied the painted and frescoed landscapes of Paul Bril, an Antwerp painter who had established himself as the leading landscape painter in the city. Later Poelenburgh moved to Florence, where he was in the service of the Medici. He painted biblical and mythological scenes set in sunny Italian landscapes created with a bright palette and delicate gradations of tone: *Landscape with the Flight into Egypt* (1625: FIG. 26) is an outstanding example of his early style. In this picture, Poelenburgh has carefully balanced the composition with the Holy Family placed on the left, their progress observed by a shepherd. On the right is a group of antique ruins, based on drawings Poelenburgh had made in Rome. The left-hand side of the landscape is in shadow, providing a foil for the Holy Family, while the right side is in sunlight. Beyond the foreground scene stretches a sunny, open plain.

Poelenburgh's distinctive figures are idealised in the High Renaissance manner, recalling the statement of his friend Sandrart that in Rome the artist had 'exerted himself to the utmost to paint his figures in the manner of Raphael'. Poelenburgh enjoyed great and lasting success; his work was in demand in Utrecht – he had an important local patron, Baron van Wyttenhorst – as well as at the courts in The Hague and London. Between 1637 and 1641 he worked for Charles I. He also painted figures in the landscapes of his contemporaries. A particularly successful collaboration was with Jan Both in *Landscape with the Judgement of Paris* (*c*.1645-50: London, National Gallery). As a highly successful artist, Poelenburgh had numerous pupils and followers. Dirck van der Lisse (1607-1669), who painted *Sleeping Nymph* (FIG. 27), was born in

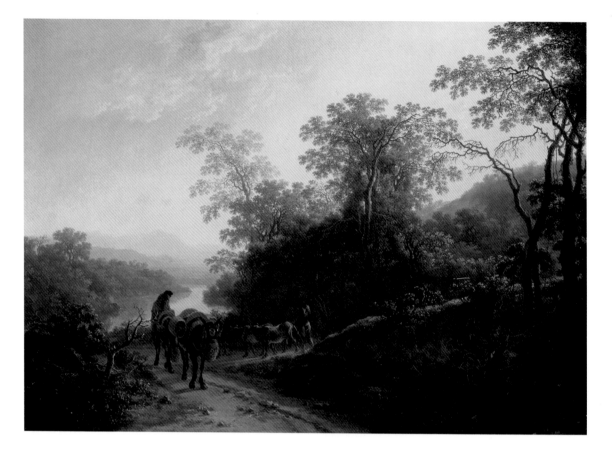

28 Jan Both
Peasants with Mules and Oxen
*on a Track near a River, c.*1642-3
Oil on copper, 39.6 x 58.1 cm
London, National Gallery

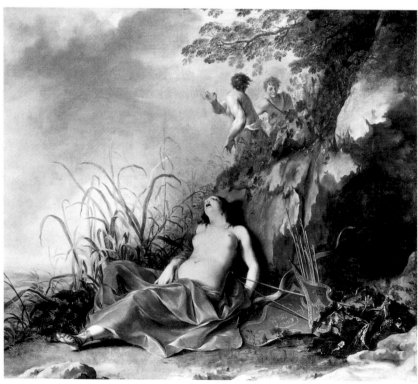

27 Dirck van der Lisse
*Sleeping Nymph, c.*1645
Oil on panel, 44 x 51.8 cm
The Hague, Mauritshuis

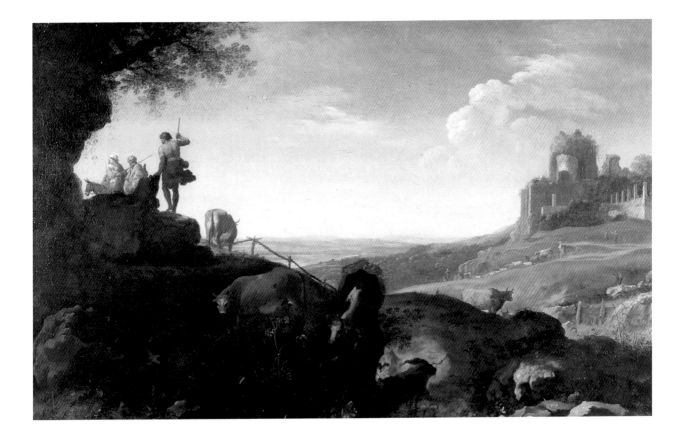

26 Cornelis van Poelenburgh
Landscape with the Flight into Egypt, 1625
Oil on canvas, 48 x 72 cm
Utrecht, Centraal Museum

25 Cornelis van Poelenburgh
*Portrait of Susanne van Collen as
a Shepherdess*, c.1626
Oil on copper, 10 x 8 cm
Baltimore, The Walters Art Gallery

29 Jan Baptist Weenix
Mother and Child in an
Italian Landscape, c.1650
Oil on canvas, 66.7 x 80 cm
The Detroit Institute of Arts

The Hague but trained in Utrecht with Poelenburgh. Subsequently, he returned to his native city and worked for the Orange court.

Jan Both (*c.*1615-1652) and his brother Andries, like so many Utrecht artists, were pupils of Bloemaert. The two young painters travelled to France and Italy and were in Rome from 1638 until 1641. After Andries's death in Venice in 1642, Jan returned to Utrecht, where he painted idyllic landscapes bathed in sunlight which are based on drawings he had made in the Roman Campagna. *Peasants with Mules and Oxen on a Track near a River* (FIG. 28), painted in highly refined detail on copper, is a superb example of his work. Jan Both was immensely influential on the development of landscape painting not just in Utrecht but throughout the Northern Netherlands.

Jan Baptist Weenix (1621-1663) had been a pupil of Bloemaert in Utrecht and was in Rome in the 1640s. Among his patrons was Cardinal Pamphilj, later Pope Innocent X. Weenix, who after his Italian years always signed himself 'Giovanni Battista Weenix', developed a highly original approach to the depiction of landscapes, harbour scenes and portraits. As in *Mother and Child in an Italian Landscape* (FIG. 29), he often transposed his Dutch subjects from Utrecht to the Roman Campagna, placing them in settings which he evoked with the help of drawings he had made there. Weenix also made a number of delicate still lifes, among them the *Dead Swan* (1650: Heino-Wijhe, Hannema-de Stuers Foundation).

6 Genre Painting, Marine Painting and Still Life

What sets the Utrecht School apart from other local schools in the Dutch Republic is its strongly Italianate character. However, this is not to say that traditionally Northern types of painting were not in demand. Wtewael, Moreelse, Honthorst, Bijlert and others painted portraits, and there were specialists in genre scenes, marines and seascapes, and still life at work in the city.

Joost Cornelisz. Droochsloot (after 1585-1666) painted small-scale figure scenes in a style which owed far more to Flanders than to Italy, which he never visited. He must have been present in 1618 when Prince Maurits formally disbanded the Utrecht mercenary companies in the city's main square, which was close to his family home. He made several paintings of the event, meeting a demand for a visual record of this key moment in the city's history. The greater part of his work, however, is made up of modest genre scenes, showing peasant interiors and village streets.

Two brothers from Rotterdam, Cornelis (1607-1681) and Herman Saftleven (1609-1685), worked together in Utrecht in the second half of the 1630s, creating peasant scenes in which Herman painted the settings and Cornelis the animals. This proved to be a short-lived collaboration, as Cornelis returned to Rotterdam in 1637, but Herman stayed in Utrecht, specialising in mountainous landscapes based on those of the Rhineland, which he visited and drew on a number of occasions.

A surprising feature of the Utrecht School is the lack of artists who painted elegant interior scenes of the kind created by Jan Vermeer in Delft, Pieter de Hooch in Delft and Amsterdam, Gerard Dou and Frans van Mieris in Leiden, Gabriel Metsu in Leiden and Amsterdam, and Gerard ter Borch in Deventer. The explanation seems to be that most of these artists did their best work after 1650, at a time when the Utrecht School was in decline and paintings were increasingly imported into the city. The one Utrecht painter of interiors, Jacob Duck (c.1598-1667), specialised in

30 **Jacob Duck**
Soldiers Arming Themselves,
*c.*1635
Oil on panel, 43 x 57 cm
The Minneapolis Institute
of Arts

scenes showing soldiers in guard-rooms. A pupil of Droochsloot, he had
studied the work of the Amsterdam painters of these subjects, Willem
Duyster and Pieter Codde. Duck was a skilful painter of contrasting
materials, carefully describing satin, lace and leather. His soldiers stand
in sparsely furnished rooms, awaiting the call to arms (FIG. 30).

There was only one significant painter of marine scenes in Utrecht,
Adam Willaerts (1577-1664). Born in Antwerp, he took the Flemish style
of seascape painting to Utrecht. Willaerts, who had no competitors in this
speciality there, continued to paint Flemish seascapes long after this style
had been superseded by more naturalistic representations of shipping and
the sea elsewhere in the Netherlands.

Still life was not a native strength of Utrecht painting, but a number
of artists in the city practised this speciality. Ambrosius Bosschaert the
Elder (1573-1621) had created a new type of simple, carefully composed
still life in Middleburg. In 1615, he was recorded as living in Utrecht, and
he spent several years there before finally settling in Breda. Similarly, his

pupil and brother-in-law Balthasar van der Ast (1593/4-1657) joined the
painters' guild in Utrecht in 1619 and remained in the city until 1632.
Both enjoyed success there. In his *Flowers in a Vase with Shells and Insects*,
(*c.*1628-30: London, National Gallery) van der Ast shows a bouquet of rel-
atively common flowers, including tulips, wallflowers, a rose and a carna-
tion,
in a small ceramic vase standing on a ledge. Beside it are three shells –
enthusiastically collected in the Netherlands in the seventeenth century –
a few fallen petals and a grasshopper. These still lifes were valued by
contemporaries both for their descriptive realism and for their decorative
qualities.

Another immigrant to Utrecht was Roelandt Savery (1578-1639),
who had worked at the court of Rudolf II in Prague. Savery had been sent
by the Emperor to draw the flora and fauna of the Tyrol, an experience
which had an immense impact on his work. He had settled in Utrecht by
1618 and remained in the city until his death twenty years later. Savery
painted flower still lifes and scenes with animals and birds often set in
landscapes. His style is highly individual, reflecting the Mannerism of
Prague as well his close observation of natural phenomena. This mixture
of fantasy and naturalism can be seen particularly clearly in his *Landscape
with Birds* (1622: Prague, National Gallery).

7 The End of the Utrecht School

B y 1650, the great age of Utrecht and of Utrecht painting was over. The economy had been stagnant for some years, and the First English War (1652-4) compounded the city's difficulties. There were a number of bankruptcies among artists – Adam Willaerts, for example, went bankrupt in 1653 – and many young Utrecht painters left for more vibrant artistic centres, above all, Amsterdam. Those who stayed on – among them Bijlert and Poelenburgh – repeated long-established compositional and stylistic formulae.

It was not just that the faltering economy had reduced the number of collectors in the city. In order to sustain a 'school' of painting, it is necessary to have enough painters in a city in order to create a lively artistic scene and a valuable exchange of ideas. Once the number of active painters falls below the level essential to maintain a vigorous and independent artistic community, a decline takes place. This seems to have been what happened in Utrecht in the second half of the century and as a consequence the Utrecht school descended into provincialism.

It had been a short but brilliant flowering. Stimulated by the Mannerism of Fontainebleau and Prague, the Caravaggism of Rome and the landscape of Italy itself, three generations of Utrecht painters had made their distinct and remarkable contribution to the Golden Age of Dutch painting.

Detail of figure 7
Joachim Wtewael
The Judgement of Paris, 1615

Biographies of the Artists

These biographies are based on those written by Marten Jan Bok for the exhibition, catalogue, *Masters of Light: Dutch Painting in Utrecht during the Golden Age*, San Francisco, 1997.

Balthasar van der Ast (1593/4-1657)

Born in Middelburg, van der Ast studied there with his brother-in-law, the still-life painter *Ambrosius Bosschaert*. Having followed Bosschaert to Utrecht, he was first recorded there in the summer of 1618. He joined the painters' guild in the following year. Van der Ast stayed in Utrecht for fifteen years and played an important part in the city's artistic life. He was very close to *Roelandt Savery*, whose house he is said to have visited frequently and with whom he shared an interest in flowers and animals. In 1632, he moved to Delft, where he remained until his death.

Van der Ast was a still-life painter who worked in a highly finished manner. He continued Bosschaert's style of precise description of fruit and flowers arranged in compositions carefully balanced in form and colour. During his long career, his compositions gradually become larger and more complex, often including rare and exotic fruits, flowers, shells and insects.

Dirck van Baburen (c.1595-1624)

Although he was probably born in Wijk bij Duurstede, Baburen's family moved shortly thereafter to Utrecht, where he was registered as an apprentice to *Paulus Moreelse* in 1611. After training in Utrecht, Baburen travelled to Italy where he was recorded in Parma in 1615. He went on to Rome, where he and David de Haen received a commission to decorate a chapel in S. Pietro in Montorio in 1617. Baburen enjoyed considerable success in Rome; among his patrons were Vincenzo Giustiniani and Scipione Borghese. Back in Utrecht around 1621, he was immediately in demand. Baburen contributed to a series of portraits of Roman emperors by leading Dutch and Flemish painters. Praised by Constantijn Huygens as one of the best painters of his generation, Baburen died in 1624, perhaps a victim of the plague which ravaged the city in that year.

Baburen was one of the leading Caravaggesque painters, having studied the work of Caravaggio and his followers in Italy. He painted religious and mythological subjects and also genre scenes and single figures of drinkers and musicians.

Jan van Bijlert (1597/8-1671)

Born in Utrecht, the son of a glass painter, Bijlert was trained in his father's profession. He entered the studio of *Abraham Bloemaert* in the early 1610s. After completing his training, he travelled to France and Italy. He was in Rome in 1621, living in the Via Margutta with three other Netherlandish artists. He was one of the founding members of the *Bentvueghels*, the society of Netherlandish artists there. Bijlert was back in Utrecht by 1624 and remained in the city for the rest of his long life. He served as dean of the painters' guild for the first time in 1632 and became a regent of St Job's Hospice in 1634.

Bijlert was a figure painter and portraitist. After his return from Italy, he worked in a Caravaggesque style, but, like Honthorst, subsequently softened that style to a more classicising manner.

Detail of figure 13
Hendrick ter Brugghen
Saint Sebastian Attended by Saint Irene, 1625

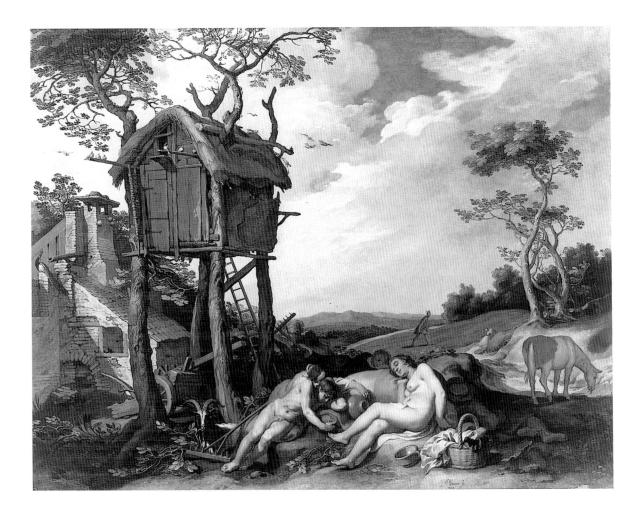

Abraham Bloemaert (1566-1651)

Bloemaert was born in Gorinchem, but his family
moved shortly afterwards to 's Hertogenbosch,
where his father, Cornelis, a sculptor and architect,
worked on the restoration of the Sint Janskerk. In
1576 the family was in Utrecht, where Abraham
studied with Joos de Beer. In 1581 or 1582, he
went to Paris, but he was back in Utrecht in the
mid-1580s and working for his father. Cornelis
Bloemaert was appointed city engineer of
Amsterdam in 1591; Abraham went there with
him and produced his first independent paintings.
He returned to Utrecht after his father's death in
1593 and was appointed dean of the saddlers'
guild. Bloemaert was a dedicated teacher; he

31 Abraham Bloemaert
Parable of the Wheat and the Tares, 1624
Oil on canvas, 100.4 x 132.5 cm
Baltimore, The Walters Art Gallery

trained his four sons to be painters, and among
his other pupils were *Hendrick ter Brugghen,
Gerard van Honthorst, Cornelis van Poelenburgh,
Jan van Bijlert, Jan Both* and *Nicolaus Knüpfer.*
Many of these artists must have taken drawing
lessons at the Utrecht 'academy'. Bloemaert, a
devout Catholic, worked for the Jesuits and
Catholic patrons in the Southern Netherlands.
A widely respected figure, his studio was visited
by Elizabeth Stuart, the 'Winter Queen', in 1626

and by Rubens in the following year. His collected drawings, published as the *Tekenboek* (Drawing Book), were used in the training of artists until the nineteenth century.

Bloemaert painted religious and mythological scenes as well as subjects from classical history, genre scenes and landscapes. His early works are in a Mannerist style but subsequently he adopted the Caravaggism of his pupils who had returned from Rome and then the prevailing classicism.

Ambrosius Bosschaert the Elder
(1573-1621)

He was born in Antwerp but, for religious reasons, Bosschaert's family moved shortly after 1587 and settled in Middelburg. There he became a still life painter and also worked as an art dealer. He left Middelburg shortly after 1611 and was recorded in a number of cities before settling in Breda in 1619. He was in Utrecht between 1615 and 1619, having arrived at a time of great interest in flowers and botanical illustration, as is evidenced by the publication of Crispijn van de Passe's *Hortus Floridus* in 1614. One of Bosschaert's pupils in Middelburg was his brother-in-law, *Balthasar van der Ast*, who spent fifteen years in Utrecht.

Bosschaert developed a new type of flower painting in which individual blooms are precisely described with the skill of a botanical illustrator, yet grouped together and carefully balanced in form and colour. His distinctive style was continued by van der Ast and by his three sons, Ambrosius the Younger, Johannes and Abraham, all of whom trained in his studio.

Jan Both (*c*.1615-1652)

Born in Utrecht, Both and his elder brother Andries were apprenticed to *Abraham Bloemaert* and studied at the Utrecht 'academy' in the mid-1620s. The two brothers travelled to Italy. Andries is recorded there from 1635, Jan from 1638. They shared a house in the Strada Vittoria from 1639

until 1641. They then travelled to Venice, where Andries died in March 1642. Jan returned to Utrecht shortly afterwards. He joined the Painters' College, serving as an officer in 1649, and had a number of pupils, including Hendrick Verschuring.

Both was a landscape painter and etcher whose style was profoundly influenced by the landscape painting he had seen in Italy and by his experience of the countryside around Rome. In Italy, he and his brother collaborated, Jan painting landscapes and Andries painting figures. Later, in Utrecht, he collaborated similarly with *Nicolaus Knüpfer* and *Jan Baptist Weenix*. The Utrecht collector Baron van Wyttenhorst was an important patron of Both.

Jan Gerritsz. van Bronchorst
(1603-1661)

Bronchorst was born in Utrecht and apprenticed to the local glass painter Jan Verburgh. He travelled to France in 1620 and studied with glass painters there. He was back in Utrecht in 1622, but could only find modest commissions. In the mid-1620s he was a student at the Utrecht 'academy' where he took drawing lessons; he then began engraving and, in 1639, painting. He joined the painters' guild in the same year. By 1651 he had moved to Amsterdam, where he received major commissions for the organ shutters of the New Church, a monumental stained-glass window for the Old Church and the decoration of the Town Hall.

Bronchorst had a very successful career. Though he never gave up his first career as a glass painter, he also painted large-scale figure scenes from the Bible, mythology and classical history in a style influenced by the Caravaggism of the 1620s.

Hendrick ter Brugghen (1588-1629)

Ter Brugghen was probably born in The Hague. His father was from Utrecht, and it was there that ter Brugghen was apprenticed to *Abraham Bloemaert*. Almost nothing is known of his Italian

years, except that in 1614 he was in Milan on his way home. Ter Brugghen was registered in the painters' guild in 1616. He was much admired by his contemporaries; Constantijn Huygens listed him amongst the great painters of the Dutch Republic, and Rubens visited his studio while in Utrecht in 1627. Ter Brugghen died two years later, during one of Utrecht's recurrent plague epidemics.

Ter Brugghen is one of the outstanding figures of the great age of Utrecht painting. He had studied the work of Caravaggio and his followers in Rome and developed his own idiosyncratic version of their style. He painted religious scenes, literary and genre subjects including single figures of musicians.

Joost Cornelisz. Droochsloot
(after 1585-1666)

Born in Utrecht, he was first recorded when he entered the painters' guild in 1616. His teacher is unknown. His earliest work consisted of large figure paintings such as *The Seven Works of Mercy* of 1618 (Utrecht, Centraal Museum). Droochsloot later painted small-scale renderings of contemporary events, such as the formal disbanding of the Utrecht militias by Prince Maurits which took place in 1618, and numerous scenes of peasant life. He supplemented his income by taking on pupils, specialising in drawing lessons; one of his pupils was *Jacob Duck*.

Jacob Duck (c.1598-1667)

Duck was born in Utrecht and apprenticed to a goldsmith. He registered as a goldsmith himself, but already in 1621 was taking drawing lessons from *Joost Cornelisz. Droochsloot*. Duck joined the painters' guild in 1629. He was a Catholic; his uncle and two brothers were priests. Duck specialised in small-scale genre scenes, showing domestic interiors and guard-rooms, painted with great delicacy and high finish.

Gerard van Honthorst (1592-1656)

Born in Utrecht, the son of a painter of decorative schemes, Honthorst was first trained by his father and by *Abraham Bloemaert*. He then travelled to Italy, where he was first recorded in 1616. He enjoyed great success in Rome, where he became known as 'Gherardo della Notte' because of his night scenes illuminated by candlelight. Honthorst lodged in the palace of Vincenzo Giustiniani, for whom he painted the *Christ before the High Priest* (National Gallery, London) in 1617. Another patron was Cardinal Scipione Borghese. Honthorst returned to Utrecht in 1620, and began to build a great reputation both in the Dutch Republic and abroad. He was invited to London in 1628 to work for King Charles I. Such were the demands of the Orange court that he opened a second studio in The Hague in 1637 and moved between that city and Utrecht. In The Hague, he painted many portraits of members of the court and gave drawing lessons to aristocratic children.

Honthorst painted religious, allegorical, mythological and literary scenes as well as genre subjects. He was also greatly in demand as a portraitist. He ran large studios in Utrecht and The Hague, with many pupils and assistants, among them his brother, Willem. In his later years, his Caravaggesque style gave way to a smoother, classicising manner.

Nicolaus Knüpfer (c.1609-1655)

Born and trained in Leipzig, Knüpfer travelled to Utrecht in his late twenties in order to work with *Abraham Bloemaert*. He was an assistant in Bloemaert's studio, but subsequently established himself as a successful independent painter. Knüpfer was involved in the project to decorate Kronberg Castle with scenes of the history of Denmark and painted figures in landscapes by *Jan Both* and *Jan Baptist Weenix*. His work was admired in Utrecht and beyond; the Rotterdam painter Pieter Crijsen Volmarijn was sent to his

studio to train. Knüpfer had many pupils, whom
he charged seventy-two guilders a year. Jan Steen
is said to have studied with him.

Knüpfer painted small-scale paintings of
subjects from the Bible, literature, mythology and
everyday life in a highly original style. His figures
are often shown in dramatic poses, described with
bold strokes and flashing white highlights.

Dirck van der Lisse (1607-1669)

Born in The Hague, he was first apprenticed there
before going to Utrecht to complete his training
with *Cornelis van Poelenburgh*. Van der Lisse was
in Utrecht in 1626 and may have worked in
Poelenburgh's studio well into the 1630s. In 1635,

32 **Gerard van Honthorst**
Granida and Daifilo, 1625
Oil on canvas, 145 x 179 cm
Utrecht, Centraal Museum

as an independent artist, he contributed to the
series of paintings illustrating *Il Pastor Fido* that
was commissioned from Utrecht artists for Prince
Frederik Hendrik's palace at Honselaarsdijk. Van
der Lisse worked in The Hague and Amsterdam as
well as in Utrecht, finally settling in his hometown
in 1644. There he enjoyed a successful career in
town government. He was one of the founders of
the painters' confraternity *Pictura* in The Hague
in 1656.

Van der Lisse painted small history paintings in the manner of Poelenburgh, often showing nymphs in an Italianate landscape.

Johannes Pauwelsz. Moreelse (d.1634)

Johannes Moreelse, son of Paulus, studied with his father and may have had drawing lessons at the Utrecht 'Academy'. He was recorded in Rome in 1627 and must have received a papal commission, as he was awarded the Order of Saint Peter. He died during a plague epidemic in Utrecht.

Paulus Moreelse (1571-1638)

He was born in Utrecht and apprenticed to the Delft portrait painter Michiel van Mierevelt. Subsequently he travelled to Italy, where he received numerous portrait commissions. In 1596 he joined the saddlers' guild and in 1611 was one of the founders of the new painters' guild. Appointed its first dean, he occupied the same post on three later occasions. Moreelse had many pupils, including two of his sons, and with *Abraham Bloemaert*, taught drawing at the Utrecht 'Academy'. He was in demand as a portraitist throughout the Dutch Republic and in 1616 painted a large militia piece for the Amsterdam archers' guild.

Moreelse was an immensely successful portrait painter and a key figure in the artistic life of Utrecht. He was appointed to the city council after the triumph of the Contra-Remonstrants in 1618 and was also active as an architect.

Cornelis van Poelenburgh (1594-1667)

Born in Utrecht, Poelenburgh (or Poelenburch) trained in the studio of *Abraham Bloemaert*. He then travelled to Italy and became a founding member of the *Bentvueghels*, the society of Netherlandish artists in Rome. He enjoyed considerable success in Rome with his Italianate landscapes and was also in the service of Grand Duke Cosimo II de Medici. Poelenburgh was back in Utrecht in the mid-1620s and was recognised as one of the city's leading painters. In 1627 the States of Utrecht gave a *Banquet of the Gods* by Poelenburgh to the new Princess of Orange, Amalia van Solms; later that year, Rubens visited Poelenburgh's studio and bought a number of paintings from him. He was invited to London by King Charles I and worked there between 1637 and 1641. On his return to Utrecht, he established a large studio, taking on many pupils and producing small cabinet paintings in large numbers. The leading local collector, Baron van Wyttenhorst, owned no fewer than fifty-five paintings by him. Poelenburgh collaborated with other artists, painting figures in landscapes by *Jan Both* and in architectural interiors by Bartholomeus van Bassen.

Poelenburgh painted religious, mythological and literary subjects set in Italianate landscapes. He worked on a small scale, in a format ideal for the private collector.

Cornelis Saftleven (1607-1681)

Saftleven was born in Gorinchem, the son of Herman, a painter from Antwerp. Shortly afterwards, the family moved to Rotterdam, where Cornelis's brother, Herman, was born. They were trained by their father until his death in 1627. Herman moved to Utrecht in the early 1630s; although Cornelis joined him, he never settled there. Between 1634 and 1637, the two brothers collaborated on a number of paintings, mostly barn interiors for which Cornelis painted the animals. In 1637, Cornelis was recorded back in Rotterdam where he lived for the rest of his life. He was a successful animal painter, having a number of pupils and serving as principal officer of the Rotterdam painters' guild.

Herman Saftleven (1609-1685)

He was born in Rotterdam, the son of Herman, a painter from Antwerp. With his elder brother, Cornelis, he was trained by his father, who died

in 1627. Herman Saftleven settled in Utrecht in 1632 or 1633. His brother joined him there and between 1634 and 1637 they collaborated on a number of paintings, often barn interiors in which Herman painted the building and Cornelis the animals. Cornelis had returned to Rotterdam by 1637. Herman had a successful career in Utrecht. In 1635, he contributed to the series of paintings illustrating *Il Pastor Fido* commissioned for Frederik Hendrik's palace at Honselaarsdijk. He became a citizen of Utrecht in 1654 and joined the painters' guild, serving as dean for the first time in 1655. Saftleven made a number of trips along the Rhine to make drawings which he used for his landscapes. He became a prominent member of the Remonstrant community in Utrecht.

Saftleven painted genre scenes early in his career, but later specialised in landscapes, often based on views he had drawn during his visits to Germany.

Roelandt Savery (1578-1639)

Savery was born in Kortrijk (Courtrai) in the Southern Netherlands. His parents left for religious reasons, settling in Haarlem around 1585. Savery was trained by his elder brother Jacques, who had moved from Haarlem to Amsterdam. Roelandt travelled to Prague, where he was first recorded in 1604, and served the Emperors Rudolf II and Matthias as court painter. He visited the Tyrol and made drawings of the flora and fauna, which he was to use in his landscapes and animal paintings. He had returned to the Netherlands by 1616 and settled two years later in Utrecht, where his nephew Hans joined him as his principal assistant. His house there, which had an extensive garden, was a centre of artistic life.

Savery painted animal pictures, landscapes, mythological and religious scenes set in landscapes, and flower pieces. In the 1620s, he was one of the most successful painters in Utrecht, but later financial difficulties led to his bankruptcy in 1638.

Jan Baptist Weenix (1621-1663)

He was born in Amsterdam, the son of Jan Weines, a painter from Enkhuizen. His father died when he was very young, and Weenix was apprenticed to Jan Micker in Amsterdam, *Abraham Bloemaert* in Utrecht and, finally, Nicolaes Moeyaert in Amsterdam. In 1643, he was recorded in Rouen on his way to Rome, where he joined the *Bentvueghels*. He worked for Cardinal Giovanni Battista Pamphilj, who was elected Pope Innocent X in 1644, and his nephew, Cardinal Camillo Pamphilj. Weenix was back in Amsterdam in 1647 and subsequently always signed himself 'Giovanni Battista'. He moved to Utrecht and soon established himself as one of the city's leading painters. He was appointed an official of the Painters' College in 1649. He collaborated with *Nicolaus Knüpfer* and *Jan Both*, and also with Nicolaes Berchem. At the end of his life, Weenix left the city and lived in the castle of Ter Mey in the village of De Haar. His two sons, Jan and Gillis, both became painters.

Weenix painted figures in landscapes, port scenes and hunting pictures, often on a large scale, in a bold and dramatic manner.

Adam Willaerts (1577-1664)

Willaerts was born in Antwerp, but his family left the city for religious reasons, presumably after the fall of Antwerp in 1585, and settled in London. The artist moved to Utrecht and in 1602 was recorded as having received the commission to paint the organ shutters in the cathedral. He was active as a drawing teacher and played a leading role in the painters' guild. Willaerts received important commissions from the city and States of Utrecht and was involved in the decoration at Kronberg Castle in Denmark.

In addition to marine paintings in a Flemish style, Willaerts also painted topographical views such as his huge *View of Dordrecht* of 1629 (Dordrechts Museum).

Joachim Wtewael (1566-1638)

Wtewael was born in Utrecht, the son of a glass painter. After training under his father, he moved to the studio of the painter Joos de Beer. Wtewael travelled to Italy around 1586 and in Padua entered the service of the Bishop of St Malo, with whom he returned to France two years later. Wtewael was probably back in Utrecht just before 1592. He joined the saddlers' guild, set up a studio and began to take on pupils. Wtewael received important commissions, including one from the States of Holland for a stained-glass window in the S. Janskerk in Gouda. He was not, however, a full-time artist: he was also a successful trader in flax. He was closely associated with the Contra-Remonstrant party and succeeded his brother Jan as a city councillor in 1630. After his death, his son Pieter, who was trained as a painter, carried on the family flax business, while another son, Jan, directed the studio.

Joachim Wtewael painted religious and mythological subjects in a highly refined Mannerist style. He often painted with great intricacy and precision on small oak and copper panels.

Pieter Wtewael (1596-1660)

Born in Utrecht, he was the eldest son of the painter Joachim, who was probably his teacher. All his dated paintings are from the 1620s. Later he gave up painting and devoted himself to the family flax business. He succeeded his father as a city councillor in 1636, at the beginning of a long career in civic government. He also served as a magistrate and as a deacon of the Reformed Church. The inventory of Wtewael's possessions made after his death listed many of his father's paintings as well as pictures by himself and other Utrecht artists.

Pieter Wtewael was trained by his father and worked in his father's Mannerist style. His rare paintings include depictions of arcadian shepherds and shepherdesses.

Detail of figure 24
Abraham Bloemaert
Adoration of the Magi, 1624

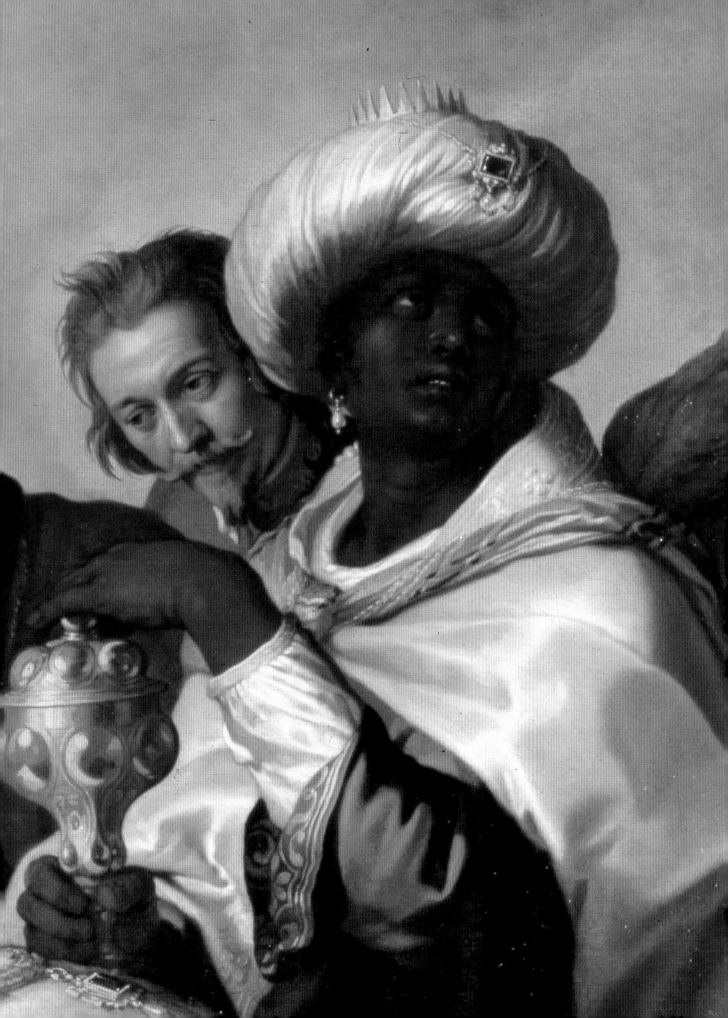

Suggestions for Further Reading in English

J. Spicer, Ed., *Masters of Light: Dutch Painting in Utrecht during the Golden Age*, San Francisco 1997.
(A catalogue of the exhibition with entries for all the paintings, essays on different aspects of the history and art of Utrecht, and a full bibliography on Utrecht painting.)

HISTORICAL STUDIES

J. Israel, *The Dutch Republic: Its Rise, Greatness and Fall 1477-1806*, Oxford 1995.

B. J. Kaplan, *Calvinists and Libertines: Confession and Community in Utrecht, 1578-1620* Oxford 1995.

GENERAL ACCOUNTS OF DUTCH SEVENTEENTH-CENTURY PAINTING

B. Haak, *The Golden Age: Dutch Painters of the Seventeenth Century*, New York 1984 (chapters on Utrecht painting).

S. Slive, *Dutch Painting 1600-1800*, London 1995 (chapters on Utrecht painting and a detailed bibliography.)

MONOGRAPHS ON INDIVIDUAL PAINTERS

J. Judson, *Gerrit van Honthorst*, The Hague 1959.

A. Lowenthal, *Joachim Wtewael and Dutch Mannerism*, Doornspijk 1986.

B. Nicolson, *Hendrick Terbrugghen*, London 1958.

M. Roethlisberger, *Abraham Bloemaert and His Sons*, 2 vols., Doornspijk 1993.

L. Slatkes, *Dirck van Baburen*, Utrecht, 1965.

Detail of figure 5
Nicolaus Knüpfer
Brothel Scene, c.1650

Works in the Exhibition

**AST, Balthasar van der
(1593/4-1657)**
Bouquet of Flowers, c.1630
Oil on panel, 53 x 38 cm
NEW YORK, PRIVATE COLLECTION

*Flowers in a Vase with Shells
and Insects, c.1628-30*
Oil on panel, 47 x 36.8 cm
LONDON, NATIONAL GALLERY
(on loan from a private collection)

**BABUREN, Dirck van
(c.1595-1624)**
The Mocking of Christ, 1621-2
Oil on canvas, 106 x 136 cm
UTRECHT, MUSEUM
CATHARIJNECONVENT

The Procuress, 1622
Oil on canvas, 101 x 107.3 cm
BOSTON, MUSEUM OF FINE ARTS
(M. Theresa B. Hopkins Fund)

*Young Man playing a Jew's
Harp, 1621*
Oil on canvas, 65.3 x 52.2 cm
UTRECHT, CENTRAAL MUSEUM

Emperor Titus, 1622
Oil on canvas, 70 x 53 cm
BERLIN, JAGDSCHLOSS GRÜNEWALD
(Stiftung Preussische Schlösser
und Gärten Berlin-Brandenburg)

Prometheus chained, 1623
Oil on canvas, 202 x 184 cm
AMSTERDAM, RIJKSMUSEUM

*Cimon and Pero (Roman
Charity), 1623*
Oil on canvas, 127 x 151 cm
YORK CITY ART GALLERY
(presented by F. D. Lycett Green
through the National Art
Collections Fund, 1955)

**BIJLERT, Jan van
(1597/8-1671)**
Girl teasing a Cat, c.1626
Oil on panel, 41 x 32 cm
BALTIMORE, THE WALTERS
ART GALLERY
(W. Alton Jones Foundation
Acquisition Fund)

*Mary Magdalene turning from the
World to Christ, 1630s*
Oil on canvas, 115 x 111 cm
GREENVILLE, BOB JONES UNIVERSITY
MUSEUM AND GALLERY

*Alms Gatherers of the Saint Job's
Hospice, c.1630-5*
Oil on canvas, 76.3 x 115.3 cm
UTRECHT, CENTRAAL MUSEUM

**BLOEMAERT, Abraham
(1566-1651)**
*The Marriage of Cupid and
Psyche, c.1595*
Oil on panel, 61.6 cm diameter
LONDON, ROYAL COLLECTION
(lent by Her Majesty The Queen)

Moses Striking the Rock, 1596
Oil on canvas, 80 x 108 cm
NEW YORK, METROPOLITAN MUSEUM
OF ART
(Purchase, gift of Mary V. T. Eberstadt,
by exchange, 1972)

Banquet of the Gods, 1598
Oil on canvas, 30.7 x 41.8 cm
THE HAGUE, MAURITSHUIS

The Four Evangelists, c.1615
Oil on canvas, 177.5 x 226.1 cm
PRINCETON, THE ART MUSEUM,
PRINCETON UNIVERSITY
(Fowler McCormick,
Class of 1921, Fund)

Saint Jerome in his Study, c.1622
Oil on canvas, 65 x 53 cm
MILWAUKEE, COLLECTION OF
DRS ALFRED AND ISABEL BADER

*Parable of the Wheat and
the Tares, 1624*
Oil on canvas, 100.4 x 132.5 cm
BALTIMORE, THE WALTERS
ART GALLERY
(Gift of the Dr Francis D.
Murnaghan Fund)

Adoration of the Magi, 1624
Oil on canvas, 168.5 x 194 cm
UTRECHT, CENTRAAL MUSEUM

Virgin and Child, c.1628
Oil on canvas, 63 x 51 cm
TORONTO, ART GALLERY OF ONTARIO
(on loan from a private collection)

Head of an Old Woman, c.1632
Oil on panel, 38 x 28 cm
NEW YORK, RICHARD L. FEIGEN

Amaryllis and Mirtillo, 1635
Oil on canvas, 115 x 140 cm
BERLIN, JAGDSCHLOSS GRÜNEWALD
(Stiftung Pruessische Schlosser und
Garten Berlin-Brandenburg)

**BOSSCHAERT the Elder,
Ambrosius (1573-1621)**
Bouquet of Flowers on a Ledge, 1619
Oil on copper, 28 x 23 cm
LOS ANGELES, COUNTY MUSEUM OF ART
(Mr and Mrs Edward William Carter
Collection)

**BOTH, Jan
(c.1615-1652)**
*Peasants with Mules and Oxen on
a Track near a River, c.1642-3*
Oil on copper, 39.6 x 58.1 cm
LONDON, NATIONAL GALLERY

*Italian Landscape with Artist
sketching a Waterfall, 1645-50*
Oil on canvas, 74 x 89 cm
CINCINNATI ART MUSEUM
(Mr and Mrs Harry S. Leyman
Endowment)

A Landscape with the Judgement of Paris, c.1645-50 (with figures by Cornelis van Poelenburgh)
Oil on canvas, 97 x 129 cm
LONDON, NATIONAL GALLERY

BRONCHORST, Jan Gerritsz. van
(1603-1661)
Study of a Young Woman, 1640-5?
Oil on canvas, 56.5 x 49 cm
CORAL GABLES, LOWE ART MUSEUM

BRUGGHEN, Hendrick ter
(1588-1629)
Christ crowned with Thorns, 1620
Oil on canvas, 207 x 240 cm
COPENHAGEN, STATENS MUSEUM
FOR KUNST

Calling of Saint Matthew, 1621
Oil on canvas, 102 x 137 cm
UTRECHT, CENTRAAL MUSEUM

Flute Player, 1621
Oil on canvas, 70 x 55 cm
KASSEL, STAATLICHE MUSEEN
(Gemäldegalerie Alte Meister)

Doubting Thomas, 1622-3
Oil on canvas, 108.1 x 133.2 cm
AMSTERDAM, RIJKSMUSEUM

The Deliverance of Saint Peter, 1624
Oil on canvas, 105 x 85 cm
THE HAGUE, MAURITSHUIS

A Man Playing a Lute, 1624
Oil on canvas, 100.5 x 78.7 cm
LONDON, NATIONAL GALLERY

Saint Sebastian Attended by Saint Irene, 1625
Oil on canvas, 175 x 120 cm
OBERLIN, ALLEN MEMORIAL ART
MUSEUM, OBERLIN COLLEGE, OHIO
(R. T. Miller Jr. Fund, 1953.)

The Crucifixion with the Virgin and Saint John, c.1625
Oil on canvas, 155 x 102 cm
NEW YORK, METROPOLITAN MUSEUM
OF ART

The Concert, c.1626
Oil on canvas, 99.1 x 116.8 cm
LONDON, NATIONAL GALLERY
(Purchased with the aid of the
National Heritage Memorial Fund,
the Pilgrim Trust and the National
Art Collections Fund)

Melancholia, 1627-8
Oil on canvas, 67 x 46 cm
TORONTO, ART GALLERY OF ONTARIO
(on loan from a private collection)

Singing Girl, 1628
Oil on canvas, 79 x 66 cm
BASEL, KUNSTMUSEUM
(Öffentliche Kunstsammlung)

Democritus, 1628
Oil on canvas, 85 x 70 cm
AMSTERDAM, RIJKSMUSEUM

Heraclitus, 1628
Oil on canvas, 86 x 70 cm
AMSTERDAM, RIJKSMUSEUM

The Annunciation, 1629
Oil on canvas, 216.5 x 176.5 cm
DIEST, STEDELIJK MUSEUM
(Openbaar Centrum voor
Maatschappelijk Welzijn van Diest)

DROOCHSLOOT, Joost Cornelisz.
(after 1585-1666)
Saint Martin dividing his Cloak, 1623
Oil on panel, 58 x 85 cm
AMSTERDAM, RIJKSMUSEUM

DUCK, Jacob
(c.1598-1667)
Soldiers Arming Themselves, c.1635
Oil on panel, 43 x 57 cm
MINNEAPOLIS, INSTITUTE OF ARTS
(The Ude Memorial Fund and Gift
of Bruce B. Dayton)

Lady World, 1640s
Oil on panel, 38.4 x 39.7 cm
SAN FRANCISCO, PRIVATE COLLECTION

HONTHORST, Gerard van
(1592-1656)
Denial of Saint Peter, c.1620-25
Oil on canvas, 110.5 x 144.8 cm
MINNEAPOLIS, INSTITUTE OF ARTS
(The Putnam Dana McMillan Fund)

A Soldier and a Girl, c.1622
Oil on canvas, 82.6 x 66 cm
BRAUNSCHWEIG, HERZOG ANTON
ULRICH - MUSEUM

Musical Group by Candlelight, 1623
Oil on canvas, 117 x 146.5 cm
COPENHAGEN, STATENS MUSEUM
FOR KUNST

Saint Sebastian, c.1623
Oil on canvas, 101 x 117 cm
LONDON, NATIONAL GALLERY

Allegory of Spring, c.1624-6
Oil on canvas, 130 x 113 cm
MUNICH, GALERIE ARNOLDI -LIVIE

Granida and Daifilo, 1625
Oil on canvas, 145 x 179 cm
UTRECHT, CENTRAAL MUSEUM

Artemesia, 1632–5
Oil on canvas, 170 x 147.5 cm
PRINCETON, THE ART MUSEUM,
PRINCETON UNIVERSITY
(Museum purchase, gift of George L.
Craig, Jr., Class of 1921, and Mrs Craig)

Frederik V, King of Bohemia, as a Roman Emperor, c.1635
Oil on canvas, 73.7 x 57.2 cm
LONDON, NATIONAL PORTRAIT
GALLERY

KNÜPFER, Nicolaus
(1609-1655)
Diana emerging from the Bath, c.1645 (with Willem de Heusch, c.1625-1692)
Oil on panel, 60 x 74 cm
PRAGUE, NATIONAL GALLERY

Brothel Scene, c.1650
Oil on panel, 60 x 74.5 cm
AMSTERDAM, RIJKSMUSEUM

LISSE, Dirck van der
(1607-1669)
Sleeping Nymph, c.1645
Oil on panel, 44 x 51.8 cm
THE HAGUE, MAURITSHUIS

MOREELSE, Johannes Pauwelsz.
(d.1634)
A Shepherd playing Pan's Pipes,
c.1630-4
Oil on panel, 73 x 58 cm
NEW YORK, PRIVATE COLLECTION

MOREELSE, Paulus
(1571-1638)
Portrait of a Member of the Strick
Family (Dirck Strick?), 1625
Oil on canvas, 121.6 x 96.8 cm
ALLENTOWN ART MUSEUM
(Samuel H. Kress Collection)

Allegory of Vanity, 1627
Oil on canvas, 105.5 x 83 cm
CAMBRIDGE, FITZWILLIAM MUSEUM

A Shepherdess, c.1627
Oil on canvas, 70.7 x 59 cm
BELGIUM, PRIVATE COLLECTION

POELENBURGH, Cornelis van
(1594-1667)
Landscape with the Flight into
Egypt, 1625
Oil on canvas, 48 x 72 cm
UTRECHT, CENTRAAL MUSEUM

Portrait of Jan Pellicorne as a
Shepherd, c.1626
Oil on copper, 10 x 8 cm
BALTIMORE, THE WALTERS ART GALLERY

Portrait of Susanne van Collen as a
Shepherdess, c.1626
Oil on copper, 10 x 8 cm
BALTIMORE, THE WALTERS ART GALLERY

Feast of the Gods, c.1630
Oil on copper, 38 x 49 cm
THE HAGUE, MAURITSHUIS

Grotto with Lot and his Daughters,
1632
Oil on panel, 36 x 52 cm
PRIVATE COLLECTION

Arcadian Landscape with Nymphs
Bathing, 1640s
Oil on panel, 34.5 x 29.5 cm
NEW YORK, PRIVATE COLLECTION

SAFTLEVEN, Herman & Cornelis
(1609-1685, 1607-1681)
Sleeping Hunter in a Landscape,
c.1642
Oil on panel, 36.8 x 52 cm
BOSTON, ABRAMS COLLECTION

SAVERY, Roelandt
(1578-1639)
Landscape with Birds, 1622
Oil on panel, 54 x 108 cm
PRAGUE, NATIONAL GALLERY

WEENIX, Jan Baptist
(1621-1663)
Dead Swan, 1650
Oil on canvas, 155 x 142 cm
HEINO-WIJHE, HANNEMA-DE STUERS
FOUNDATION

Mother and Child in an Italian
Landscape, c.1650
Oil on canvas, 66.7 x 80 cm
DETROIT, INSTITUTE OF ARTS
(Gift of Mrs John A. Bryant
in memory of her husband)

WILLAERTS, Adam
(1577-1664)
Ships off a Rocky Coast, 1621
Oil on panel, 62 x 122.5 cm
AMSTERDAM, RIJKSMUSEUM

WTEWAEL, Joachim
(1566-1638)
Saint Sebastian, 1600
Oil on canvas, 169.2 x 125.1 cm
KANSAS CITY, NELSON-ATKINS
MUSEUM OF ART (Purchase)

Mars and Venus discovered by
Vulcan, 1601
Oil on copper, 21 x 16 cm
THE HAGUE, MAURITSHUIS

Mars, Venus and Cupid, c.1610
Oil on copper, 18.2 x 13.5 cm
AMSTERDAM, STICHTING COLLECTIE
P. EN N. DE BOER

Andromeda, 1611
Oil on canvas, 180 x 150 cm
PARIS, MUSÉE DU LOUVRE

Wedding of Peleus and Thetis,
1612
Oil on copper, 36.5 x 42 cm
WILLIAMSTOWN, STERLING AND
FRANCINE CLARK ART INSTITUTE

The Judgement of Paris, 1615
Oil on panel, 59.8 x 79.2 cm
LONDON, NATIONAL GALLERY

The Kitchen Maid (with Christ,
Mary and Martha), 1620-5
Oil on canvas, 102 x 72 cm
USA, PRIVATE COLLECTION

A Shepherdess, 1623
Oil on panel, 49.5 cm diameter
CAMBRIDGE, FOGG ART MUSEUM,
HARVARD UNIVERSITY ART MUSEUMS
(Melvin R. Seiden Purchase Fund
in honour of William W. Robinson)

A Shepherd, 1623
Oil on panel, 49.5 cm diameter
CAMBRIDGE, FOGG ART MUSEUM,
HARVARD UNIVERSITY ART MUSEUMS
(Melvin R. Seiden Purchase Fund
in honour of William W. Robinson)

WTEWAEL, Pieter
(1596-1660)
Denial of Saint Peter, c.1624-8
Oil on panel, 28 x 46 cm
CLEVELAND, MUSEUM OF ART
(Gift of Mr. and Mrs. Noah L. Butkin,
1972.169)